Vibrant Butterflies

Our Favorite Visitors to Flowers and Gardens

Jaret C. Daniels

Adventure Publications
Cambridge, Minnesota

Dedication

To my lovely wife Stephanie. She is my colleague, best friend, and the only person with whom I could ever imagine sharing my life.

Acknowledgments

I am grateful to the Florida Museum of Natural History and its Photography Department, specifically Jeffrey Gage, for providing access to an extensive photo library and for assistance with image selection.

Edited by Brett Ortler
Cover and book design by Lora Westberg
All photos by Jaret C. Daniels unless otherwise noted.

Photos courtesy of the Florida Museum of Natural History: 12-13, 15, 23, 29, 30, 37, 38, 44, 46, 47, 49, 50, 51, 60, 125

Shutterstock: 1, 3, 6, 17, 18-19, 20-21, 24-25, 32, 33, 34, 35, 40-41, 42-43, 52, 53, 54-55, 56, 57, 58, 59, 62-63, 64, 66-67, 68, 69, 70-71, 72, 73, 74, 75, 76-77, 78-79, 82, 83, 84-85, 89, 90, 91, 92, 93, 94-95, 96-97, 98, 100, 101, 102, 104-105, 106, 107, 110, 111, 112, 113, 114, 115, 116, 117, 119, 122 Monarch Caterpillar, Hickory Horned Devil, Imperial Moth Caterpillar, Cabbage White Caterpillar, Black Swallowtail Caterpillar/Parsley Worm, Monarch Butterfly, Regal Moth, Imperial Moth, Cabbage White Butterfly, Red Admiral Caterpillar, Mourning Cloak Caterpillar, Cecropia Moth Caterpillar, 123 Viceroy Caterpillar, Painted Lady Caterpillar, Question Mark Butterfly, Red-spotted Purple Butterfly, Long-tailed Skipper Butterfly, 124 Anise Swallowtail Caterpillar, Anise Swallowtail Butterfly, Variable Checkerspot Caterpillar, Eastern Tiger Swallowtail Caterpillar, White-lined sphinx Caterpillar, Variable Checkerspot Butterfly, Eastern Tiger Swallowtail Butterfly, White-lined Sphinx Moth, 126 (all except Horace's Dusky-wing), 127 (all), 128 (all), Front cover, Back cover, Front flap, Spine

10 9 8 7 6 5 4 3

Vibrant Butterflies

Our Favorite Visitors to Flowers and Gardens

Table of Contents

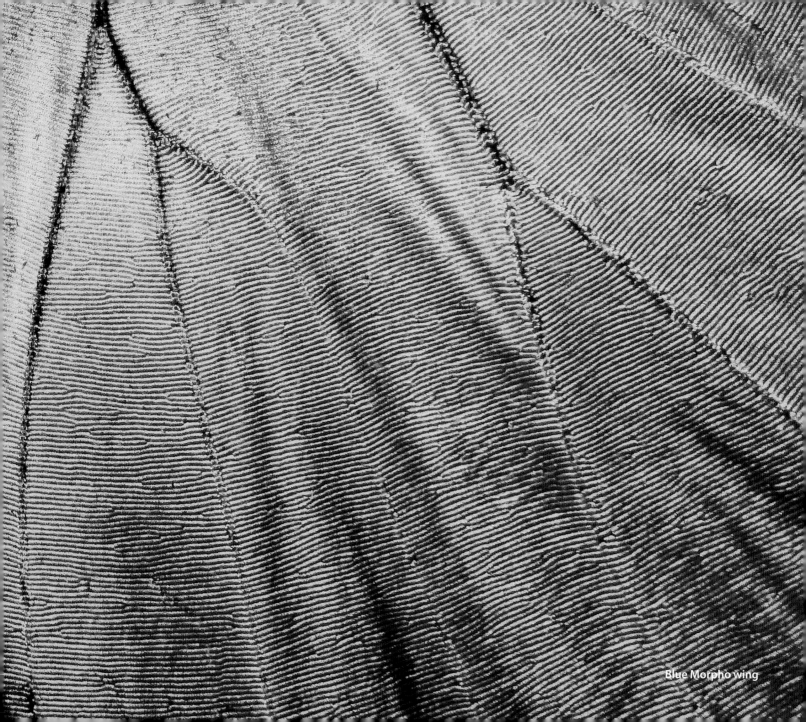
Blue Morpho wing

Our Vibrant Butterflies

Butterflies are among the most charismatic and widely recognizable insects in the world. Their beauty and allure have fascinated people and cultures around the world for millennia. Along with moths, butterflies belong to the incredibly diverse insect order Lepidoptera, which is second only to order Coleoptera (beetles and weevils) when it comes to the total number of insect species. Many are relatively large and easily identified by their prominent wings, which are covered in a myriad of flattened, overlapping, and often brightly colored scales. Of the nearly 160,000 species of Lepidoptera found worldwide, about 18,000 are butterflies. While the vast majority of butterfly diversity occurs in the tropics, North America is home to around 700 different species. In the U.S., Florida and the mountainous West are home to the most butterfly species.

EVOLUTIONARY ORIGIN Because of their fragile nature, the fossil record for butterflies is sparse. The earliest Lepidopteran specimen dates back nearly to the beginning of the Jurassic Period, around 190 million years ago. Recent scientific evidence suggests that the ancestors of modern-day butterflies and moths may have arisen millions of years earlier during the Triassic Period, and that they are most closely related to caddisflies. In any case, the ancient butterflies that were flying about alongside the dinosaurs were likely not too different from the ones found today.

Butterflies and moths diversified extensively alongside flowering plants, and today they are the largest group of herbivorous insects on the planet.

DIFFERENCES BETWEEN BUTTERFLIES AND MOTHS While most people are familiar with butterflies, moths often go relatively unnoticed, even though they are considerably more abundant and diverse. Superficially, they look quite similar. Nonetheless, there are some notable general differences between the two groups, both in terms of appearance and behavior. Butterflies are typically large, brightly colored, and active by day. In contrast, moths tend to be somewhat diminutive, more drab in appearance, and nocturnal. Because moths are active at night, they are exposed to cooler temperatures, and they therefore have adapted to have hairier, more robust bodies, which help keep them insulated. Butterflies, by contrast, are generally smoother and more slender.

COCOON VS. CHRYSALIS Moths are arguably most famous for their silken cocoons. The industrious larvae produce silk and meticulously weave it into a protective structure that surrounds them. They then pupate inside. Each cocoon is likely produced by a single strand of silk that may be thousands of feet in length; cocoon appearance varies considerably between species.

Butterflies don't produce protective cocoons. Instead, their pupae are typically naked. When a butterfly is in its pupal stage, it's sometimes referred to as a "chrysalis." Butterfly larvae do have the ability to produce silk. Silk is instead often used to firmly attach this transformative stage to a twig, leaf, or another structure.

WING POSTURE Wing posture is another way to differentiate between butterflies and moths. When at rest, butterflies routinely hold their wings together above their bodies. Moths on the other hand may fold their wings flat, somewhat tent-like over their backs, spread them outward against a leaf or another material, or may even curl them around their bodies. Moths also have a stiff bristle or a series of bristles (called a frenulum) on their hindwings; it fits into a corresponding catch on the forewing, acting as a coupling mechanism to help the wings work together as one during flight. This increases aerodynamic efficiency and speed.

Despite these differences, often the quickest and most conspicuous way to differentiate butterflies from moths is by their antennae. Butterflies have slender antennae, with a thickened club or hook at the tip. Moth antennae vary greatly. Some are thread-like, while others are noticeably feathery or even spindle-shaped with a broader middle and tapered ends.

EXCEPTIONS TO THE RULE The natural world is seldom straightforward, and hard-and-fast rules are often peppered with exceptions. Moths and butterflies certainly have their share. Although moths dominate the nocturnal environment, numerous species are also active by day. In addition, many moth species are as brightly colored or elaborately patterned as butterflies, and moths are significantly more diverse in terms of overall size and form. Some butterflies also bend the rules; some species are crepuscular (active at the low light levels during twilight) instead of flying during the day. Other butterflies are simply more muted in color or have a somewhat lackluster pattern compared to what one might expect. Exceptions also occur when it comes to resting wing posture, adult behavior, and other attributes.

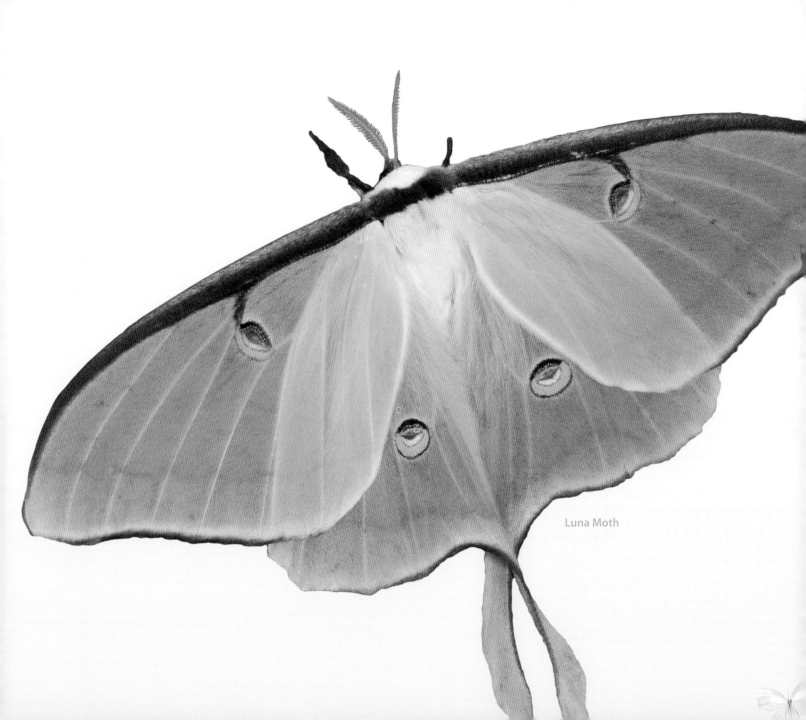

Luna Moth

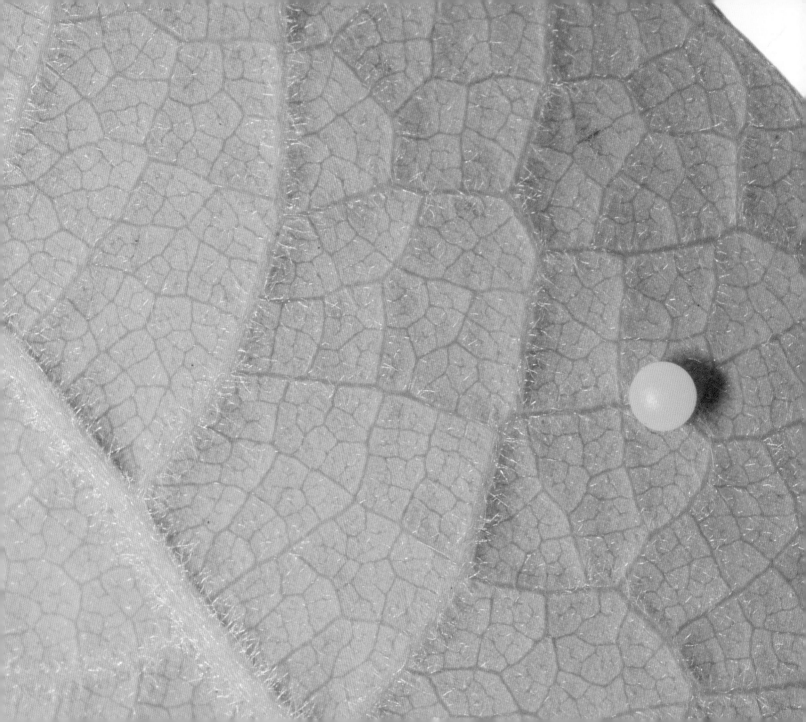

An Elegant Life Cycle

All butterflies go through a life cycle consisting of four distinct stages—egg, larva, pupa, and adult. They are one of several insect groups that undergo this complete transition. This process of metamorphosis makes butterflies seem almost magical and enhances their overall interest and appeal. It is also a key component to their evolutionary success. A caterpillar has a very different lifestyle and resource requirements than a butterfly. The developing larvae have chewing mouthparts, feed on plant material, and are generally sedentary. The winged adults are fluid feeders and are highly mobile. This enables both groups to exploit very different food resources, niches, and even habitats, all without competing against one another. This evolutionary strategy also helps them colonize new areas and enhances genetic exchange between populations.

Long-tailed Skipper egg

STAGE BY STAGE

The Egg No matter how large or small an adult butterfly is, it begins life as a tiny egg. Females deposit eggs on or near specific host plants, which have the right chemical and nutritional components to support the wormlike, plant-eating larvae once they hatch. Finding the right plant amid the maze of vegetation in the larger landscape is no simple feat, however. To do so, female butterflies rely on their keen senses of vision and smell in the search for potentially suitable host plants, honing in on specific characteristics, such as leaf shape and the volatile compounds the plants emit. Once they spot a potential host plant, they land on the plant to confirm the host, using physical and chemical cues to do so. This stimulates egg laying, and the butterfly may even select specific sites on the plant to deposit eggs.

Emerald Swallowtail,
Native to Southeast Asia

12

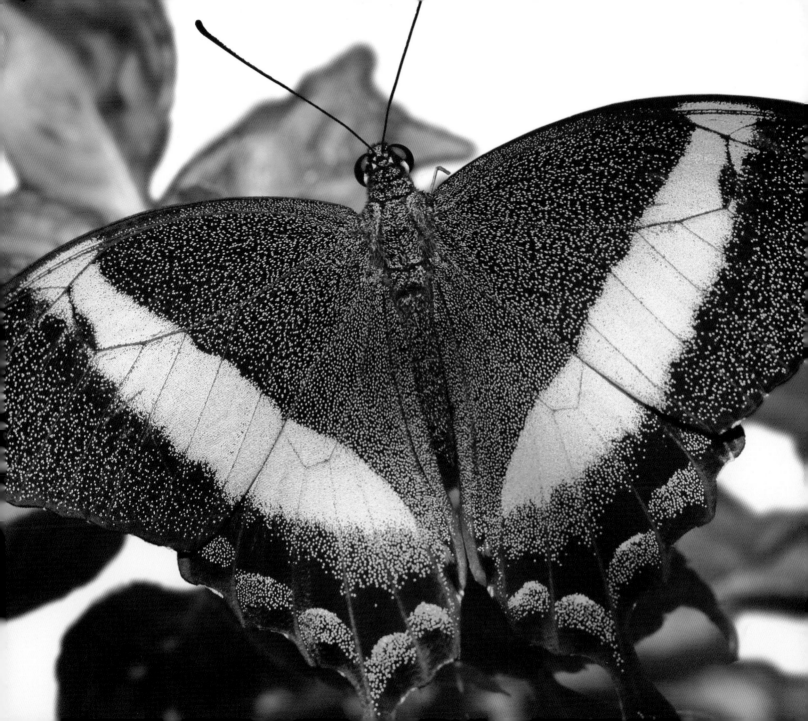

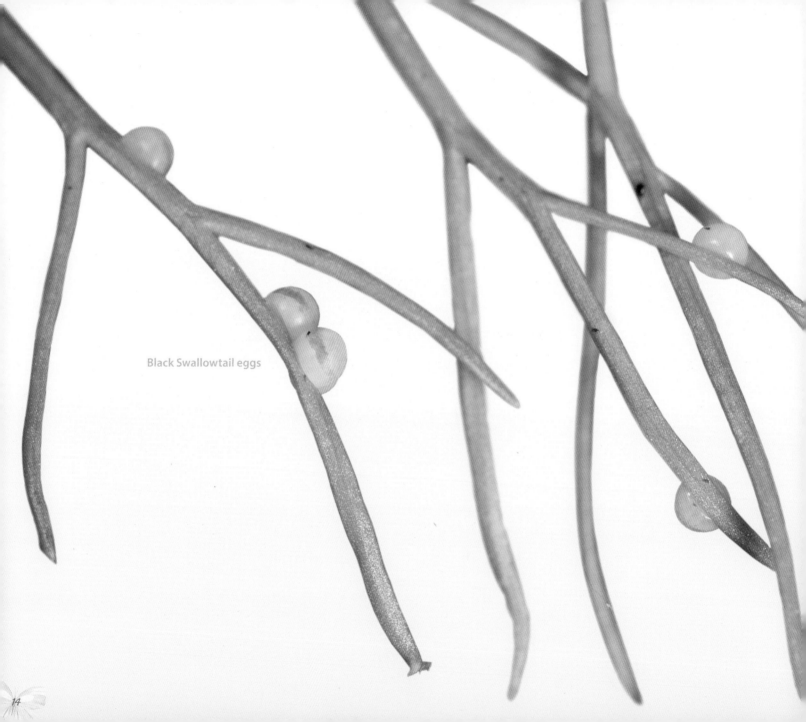

Black Swallowtail eggs

Glued In Place The females of most butterfly species use an adhesive protein secretion to securely glue their eggs to the host plant. This ensures that the eggs remain firmly attached until the young larvae eventually hatch. Some butterflies, though, employ a more haphazard strategy. They often place or drop eggs randomly near available hosts and let the small, newborn larvae navigate to the adjacent vegetation and begin feeding. In many ways, the dietary requirements of the larvae dictate where the eggs are, and often, they will hatch. Some species utilize only a particular plant part or one developmental stage of that plant as food. Some larvae feed on flowers or developing fruit, while others require tender new growth, which can be more nutritious or have a somewhat different water or chemical content compared to older leaves. One butterfly species, the Harvester, is even carnivorous, and feeds on the flesh of woolly aphids, not vegetation. As a result, timing and location are everything.

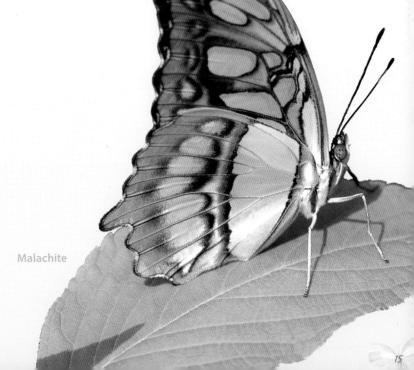

Malachite

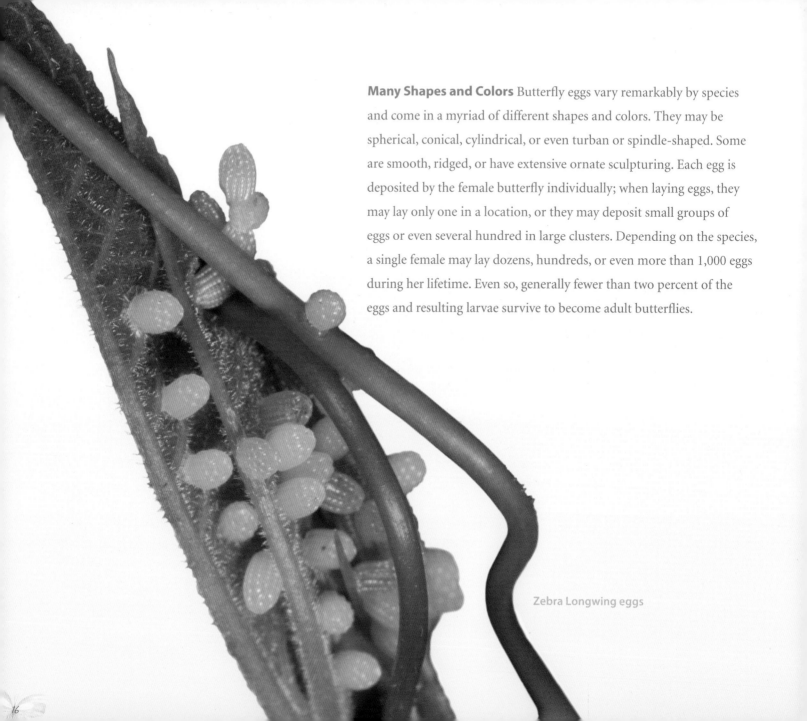

Many Shapes and Colors Butterfly eggs vary remarkably by species and come in a myriad of different shapes and colors. They may be spherical, conical, cylindrical, or even turban or spindle-shaped. Some are smooth, ridged, or have extensive ornate sculpturing. Each egg is deposited by the female butterfly individually; when laying eggs, they may lay only one in a location, or they may deposit small groups of eggs or even several hundred in large clusters. Depending on the species, a single female may lay dozens, hundreds, or even more than 1,000 eggs during her lifetime. Even so, generally fewer than two percent of the eggs and resulting larvae survive to become adult butterflies.

Zebra Longwing eggs

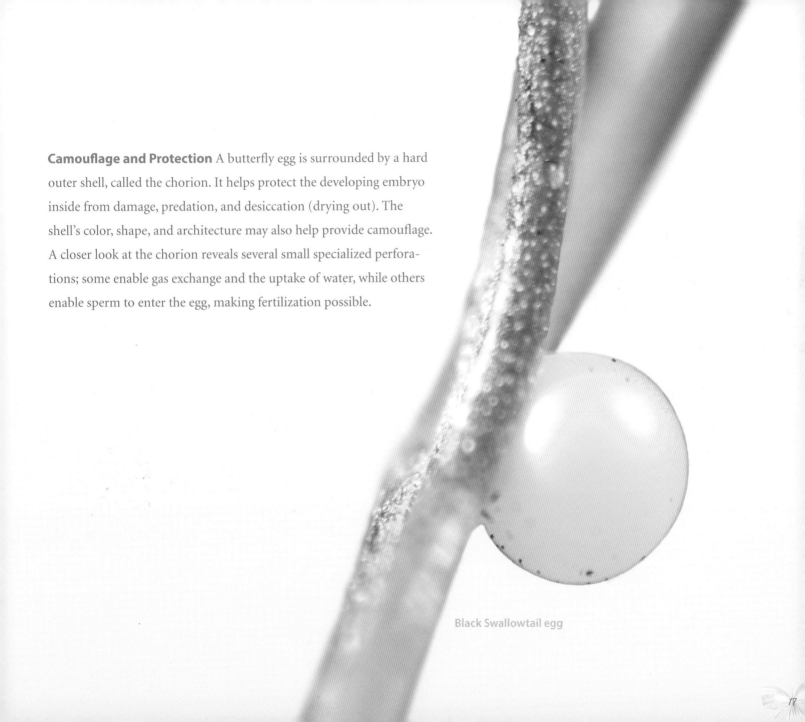

Camouflage and Protection A butterfly egg is surrounded by a hard outer shell, called the chorion. It helps protect the developing embryo inside from damage, predation, and desiccation (drying out). The shell's color, shape, and architecture may also help provide camouflage. A closer look at the chorion reveals several small specialized perforations; some enable gas exchange and the uptake of water, while others enable sperm to enter the egg, making fertilization possible.

Black Swallowtail egg

THE LARVA Inside the fertilized egg, the embryo begins developing. As it matures, the egg will often darken in color. Upon hatching, the tiny young larva begins to feed almost immediately and will continue to feed at an astonishing rate. Butterfly larvae are effectively eating machines, spending virtually all their time devouring plant material. This is now a time of rapid growth and often considerable change. Over the course of its development, a larva may increase several thousandfold in mass, all in just a few short weeks. As all insects have an external exoskeleton, this level of growth requires the larva to molt. During molting, the old skin is shed and replaced by a new skin, which is roomier and looks different. The larval stage between each molt is called an instar, and most butterfly species go through at least five larval instars as they grow.

Black Swallowtail
larva

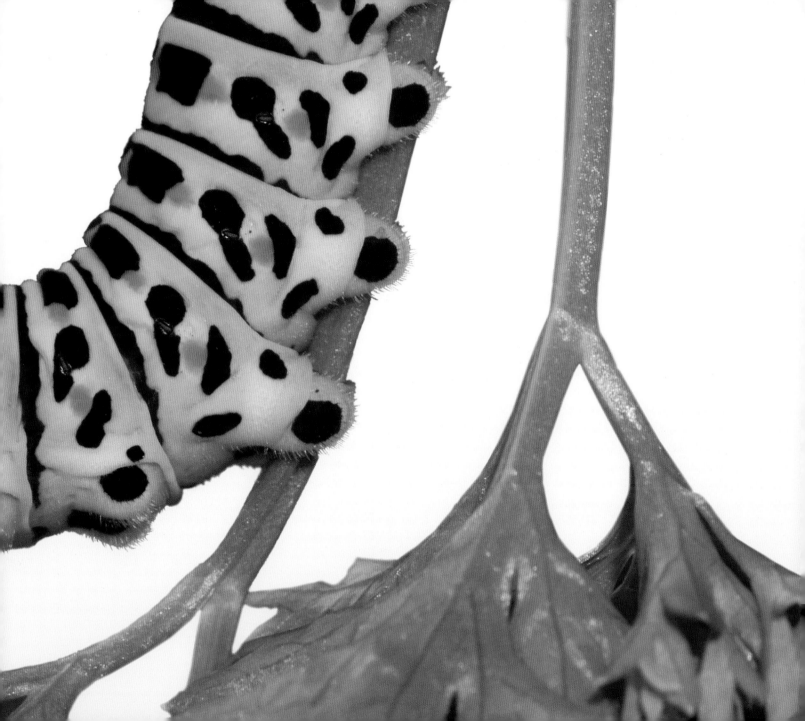

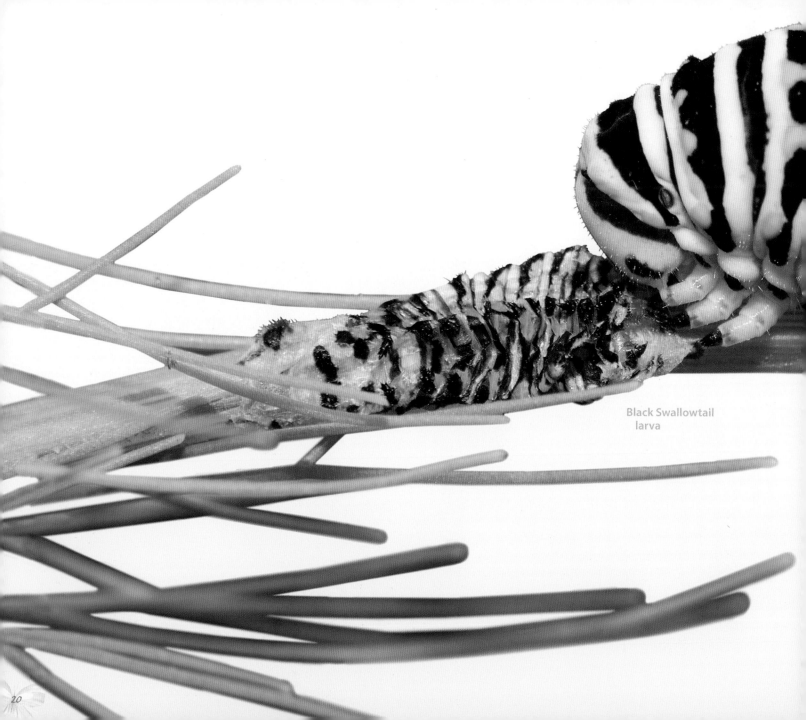

Black Swallowtail
larva

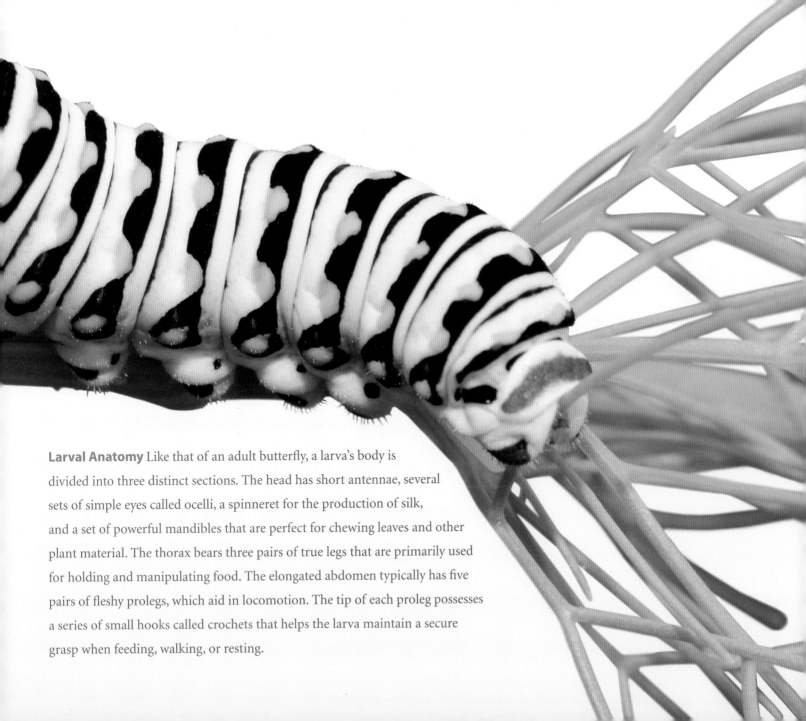

Larval Anatomy Like that of an adult butterfly, a larva's body is divided into three distinct sections. The head has short antennae, several sets of simple eyes called ocelli, a spinneret for the production of silk, and a set of powerful mandibles that are perfect for chewing leaves and other plant material. The thorax bears three pairs of true legs that are primarily used for holding and manipulating food. The elongated abdomen typically has five pairs of fleshy prolegs, which aid in locomotion. The tip of each proleg possesses a series of small hooks called crochets that helps the larva maintain a secure grasp when feeding, walking, or resting.

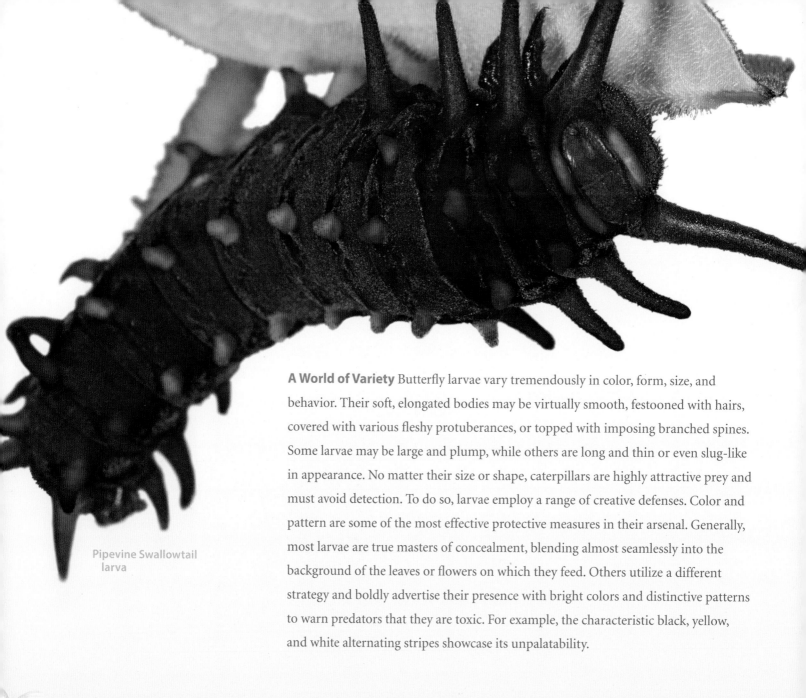

Pipevine Swallowtail
larva

A World of Variety Butterfly larvae vary tremendously in color, form, size, and behavior. Their soft, elongated bodies may be virtually smooth, festooned with hairs, covered with various fleshy protuberances, or topped with imposing branched spines. Some larvae may be large and plump, while others are long and thin or even slug-like in appearance. No matter their size or shape, caterpillars are highly attractive prey and must avoid detection. To do so, larvae employ a range of creative defenses. Color and pattern are some of the most effective protective measures in their arsenal. Generally, most larvae are true masters of concealment, blending almost seamlessly into the background of the leaves or flowers on which they feed. Others utilize a different strategy and boldly advertise their presence with bright colors and distinctive patterns to warn predators that they are toxic. For example, the characteristic black, yellow, and white alternating stripes showcase its unpalatability.

Clever Disguises Other butterflies strive to fool would-be predators by wearing a disguise of sorts. The mottled brown and White Giant Swallowtail larva resembles a bird dropping; the Spicebush Swallowtail displays elaborate false eyespots to startle approaching enemies; and the dark-colored Pipevine Swallowtail larva has slender, fleshy projections that mimic those of a venomous centipede.

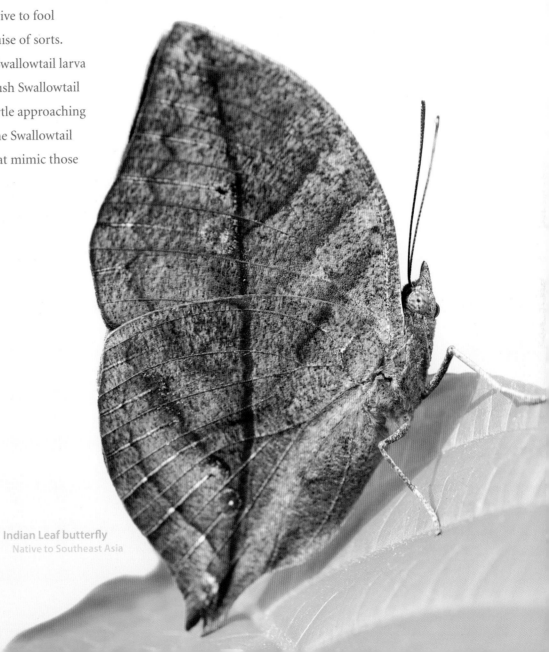

Indian Leaf butterfly
Native to Southeast Asia

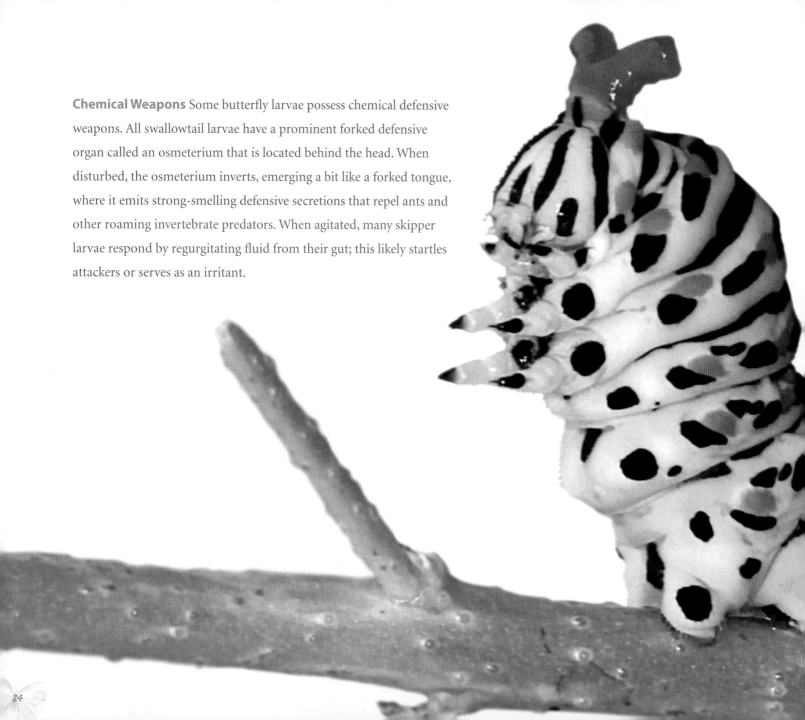

Chemical Weapons Some butterfly larvae possess chemical defensive weapons. All swallowtail larvae have a prominent forked defensive organ called an osmeterium that is located behind the head. When disturbed, the osmeterium inverts, emerging a bit like a forked tongue, where it emits strong-smelling defensive secretions that repel ants and other roaming invertebrate predators. When agitated, many skipper larvae respond by regurgitating fluid from their gut; this likely startles attackers or serves as an irritant.

Hiding Out Numerous butterfly larvae go to great lengths to conceal their presence, even constructing shelters on their hosts by folding, tying, or joining leaves or other plant parts together with silk. While the architecture and complexity vary between species, most shelters typically require a significant amount of engineering, including the precise execution of several cuts and folds. These structures may also serve as defensive battlements when the larva is under attack and help prevent it from being dislodged. They may also aid in temperature control or help the larva avoid drying out. The larval occupant ventures out periodically to feed, often doing so under the cover of darkness. As the larva grows, it builds a new shelter that is larger and often more intricate than the previous one.

Anise Swallowtail
larva

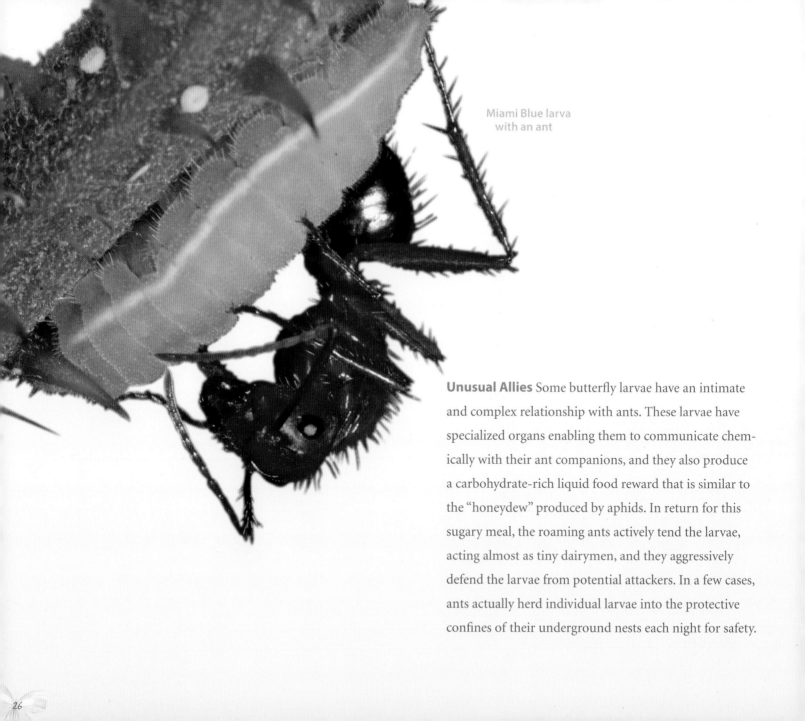

Miami Blue larva
with an ant

Unusual Allies Some butterfly larvae have an intimate and complex relationship with ants. These larvae have specialized organs enabling them to communicate chemically with their ant companions, and they also produce a carbohydrate-rich liquid food reward that is similar to the "honeydew" produced by aphids. In return for this sugary meal, the roaming ants actively tend the larvae, acting almost as tiny dairymen, and they aggressively defend the larvae from potential attackers. In a few cases, ants actually herd individual larvae into the protective confines of their underground nests each night for safety.

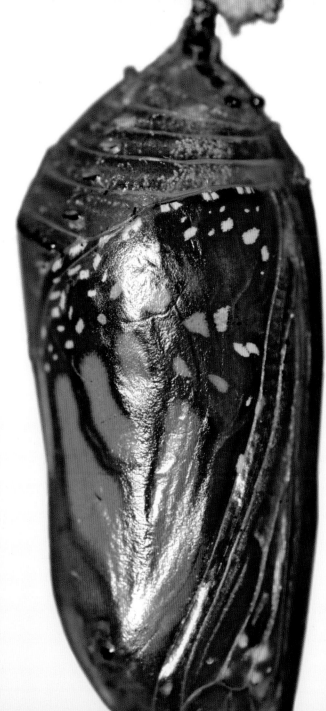

THE CHRYSALIS When fully grown, each larva seeks a secure location in which to pupate. When ready to pupate, the vast majority of butterfly larvae attach themselves with silk to a leaf, twig, or other substrate. They are now ready to molt for the final time, which reveals the chrysalis. Unlike the somewhat soft and supple larva, the chrysalis is more sturdy and hardened, which is important as the chrysalis is fixed in place and largely defenseless against predation. Therefore, most chrysalises depend on disguise and concealment. Many adeptly blend into the surroundings by resembling leaves or dead twigs and are typically hidden under vegetation or in otherwise obscure sites. Some may thrash about if disturbed or are capable of making audible squeaks or chirps to startle attackers.

Monarch chrysalis

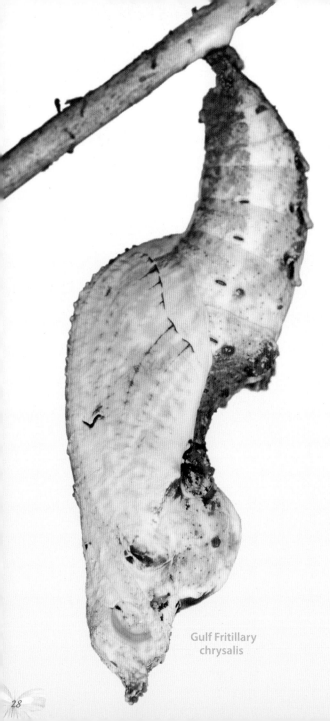

Gulf Fritillary
chrysalis

A Lot Going on Behind the Scenes The chrysalis may be sedentary, but it is a truly dynamic and transitional stage. Think of it as a radical reconstruction from one form to another. Inside the chrysalis, many tissues are broken down and completely reorganized, while other organs stay generally intact. At the same time, structures called imaginal discs, which were already present in the larva, begin growing rapidly to produce the main body parts of an adult butterfly, including the wings, legs, and head. Once the resulting internal transformation is complete, the pupa darkens and the color and pattern begins to show. This means the emergence of the adult butterfly is imminent. Soon, the pupal case will split open and the new butterfly will crawl out, a process called eclosion.

Once free, the adult butterfly will hang from the old chrysalis or a nearby structure and begin to pump hemolymph (its version of blood) into the veins of its wings. This causes them to expand rapidly. Within only a few hours, the adult's wings are fully expanded and hardened. It is now ready to fly.

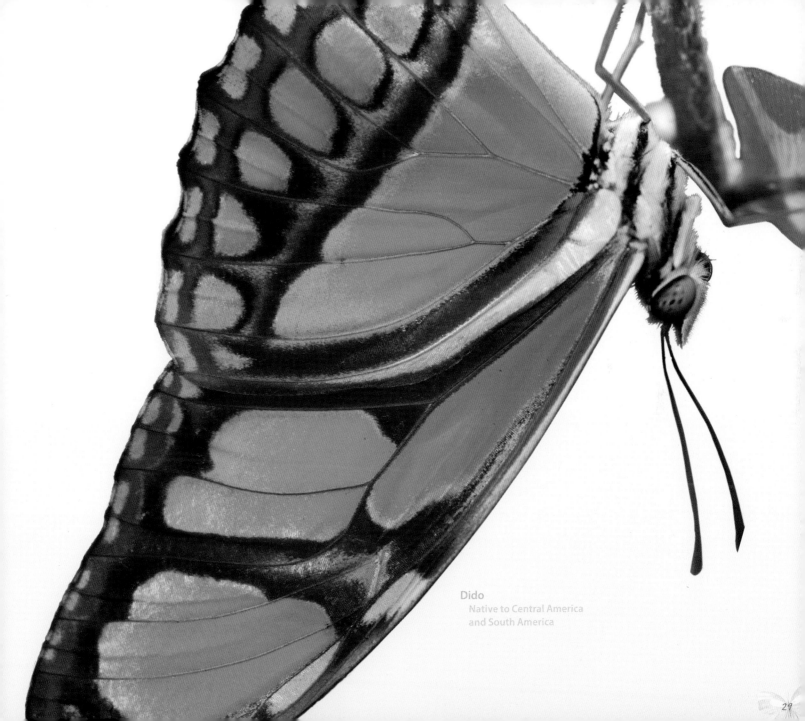

Dido
Native to Central America
and South America

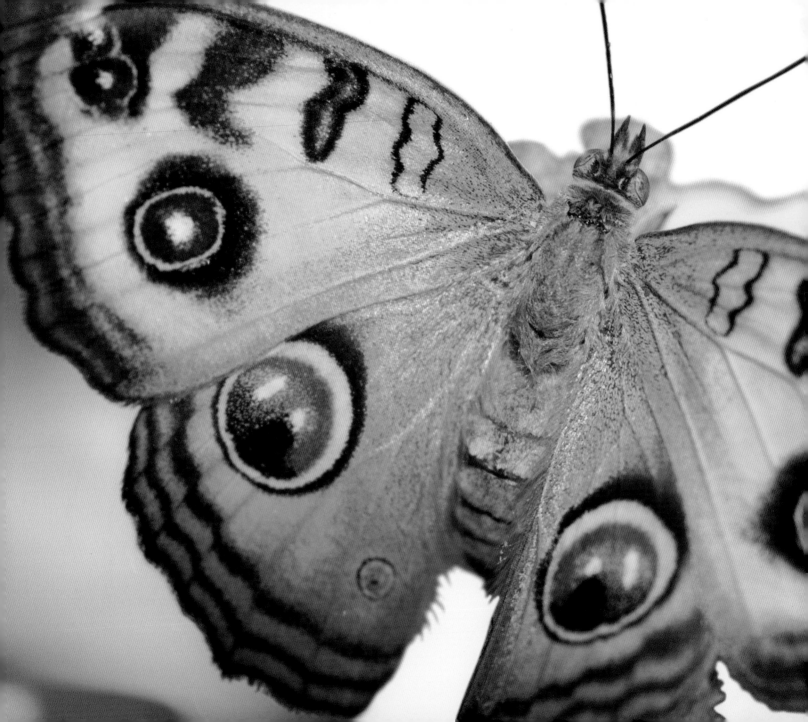

Adult Butterflies

Adult butterflies represent the reproductive stage of the butterfly's lifecycle. The adult butterfly is equipped with large, powerful wings that enable it to fly, affording it the mobility required to find a suitable mate and transport eggs across the landscape. In turn, this ensures effective gene flow, helps butterflies colonize new areas, and maintains viable populations over time. The end game is simple: the survival and success of the species.

Peacock Pansy
Native to Southeast Asia

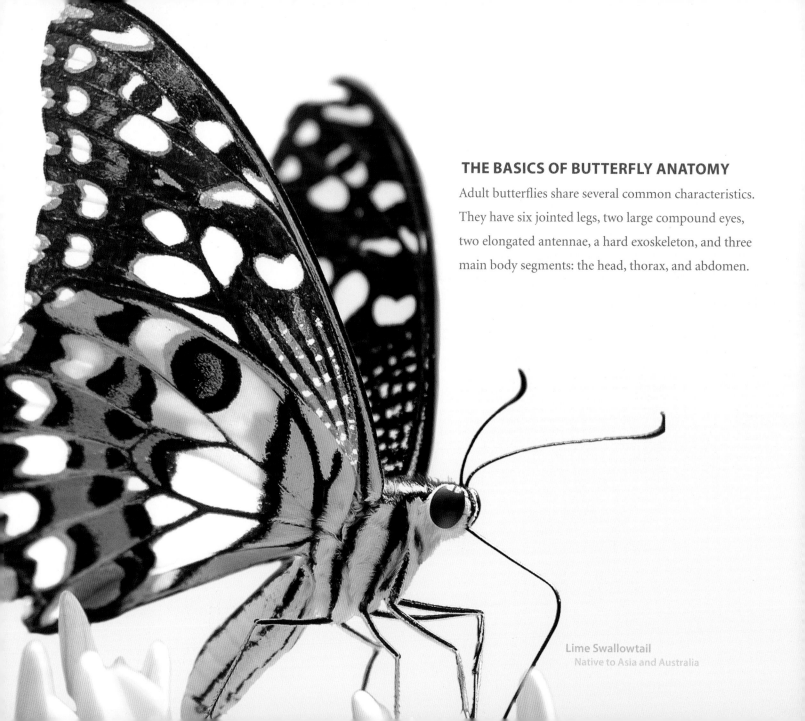

THE BASICS OF BUTTERFLY ANATOMY

Adult butterflies share several common characteristics. They have six jointed legs, two large compound eyes, two elongated antennae, a hard exoskeleton, and three main body segments: the head, thorax, and abdomen.

Lime Swallowtail
Native to Asia and Australia

A Butterfly's Head Butterflies have two rounded and conspicuous compound eyes, which are situated symmetrically, with one on each side of the head. Each is composed of hundreds of tiny individual lenses. Together, they render a single color image, albeit one that is somewhat pixelated. Above the eyes are two long and slender antennae that are clubbed at the tip. These may be the most obvious features visible at first glance. At the front of the head, below the eyes, are two protruding, brush-like structures called labial palpi. They serve to house and protect the proboscis, or tongue. The proboscis is a long, flexible, straw-like mouthpart adapted for drinking fluids such as flower nectar. It can be tightly coiled beneath the head or extended when feeding.

The Thorax Directly behind the head is the thorax. It is divided into three segments and bears six legs and four large wings. The locomotive center of the butterfly, the thorax contains strong muscles that power flight and movement.

The Abdomen The last body section is the long, generally slender abdomen. It contains the digestive, excretory, and reproductive systems along with a series of small lateral holes, called spiracles, which are tubes that transport air into its body. (Butterflies don't actually have lungs.) Female butterflies generally have larger, more plump-looking abdomens because they carry a complement of eggs.

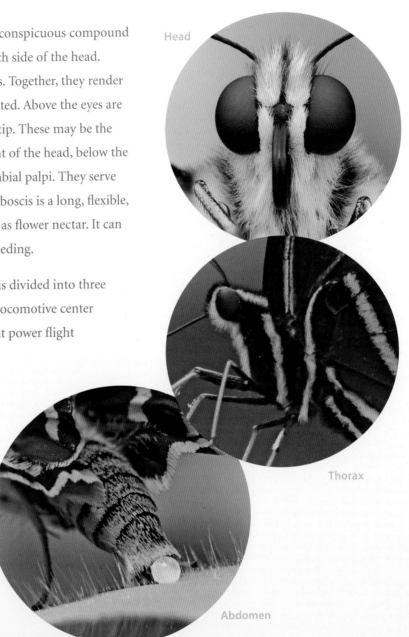

Head

Thorax

Abdomen

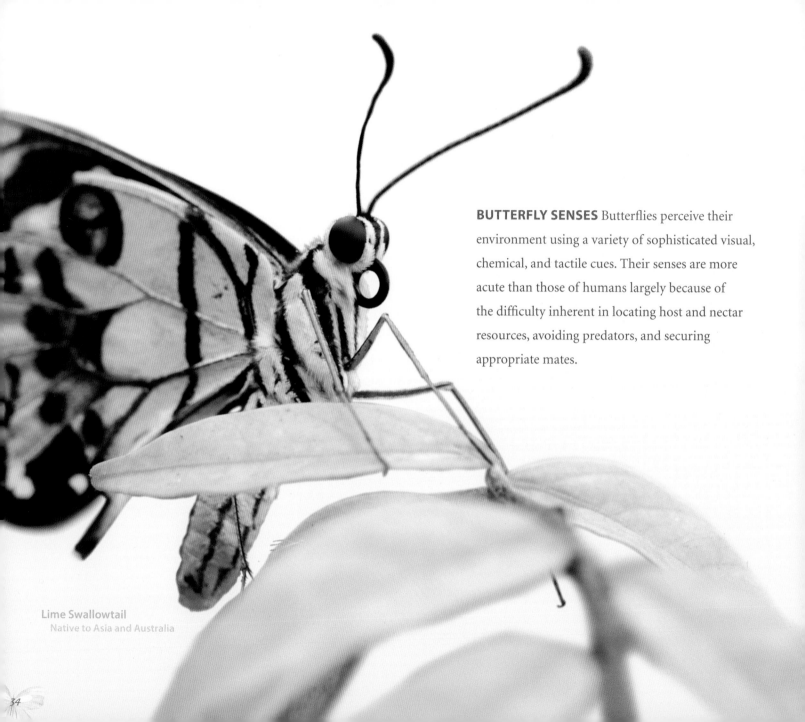

BUTTERFLY SENSES Butterflies perceive their environment using a variety of sophisticated visual, chemical, and tactile cues. Their senses are more acute than those of humans largely because of the difficulty inherent in locating host and nectar resources, avoiding predators, and securing appropriate mates.

Lime Swallowtail
Native to Asia and Australia

Vision Butterflies are visual creatures. They can see more of the visible spectrum than almost any animal and can even see ultraviolet light (UV). They also display sophisticated color vision, but some see better than others. Photoreceptor sensitivity varies extensively between butterfly species and can even vary between exes of the same species.

Seeing in Light—and Ultraviolet Butterflies likely evolved to have compound eyes because they helped make them better at finding food and detecting a potential mate. Flowers, in particular, show distinct patterns under ultraviolet light; these "nectar guides" lure in pollinators and make butterflies more efficient foragers. Butterflies also employ ultraviolet signals for species recognition. Many butterflies have complex, and often startlingly similar, wing colors and patterns. These same patterns often look very different under ultraviolet light, with different regions of the wing having UV-absorbing or UV-reflecting properties. The resulting differences, combined with subtle differences in color sensitivity, help enable particular species to identify one another and locate potential mates. This visual prowess may also help them locate specific host plants amid the variety of vegetation in the landscape.

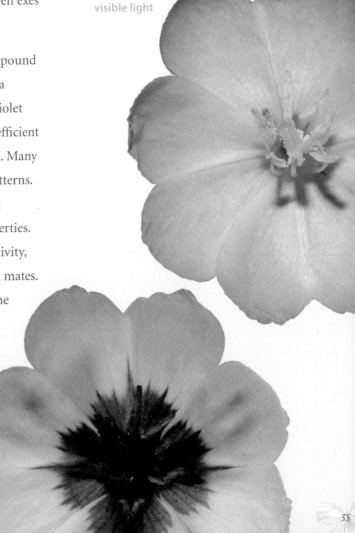

A flower in
visible light

A flower in
ultraviolet light

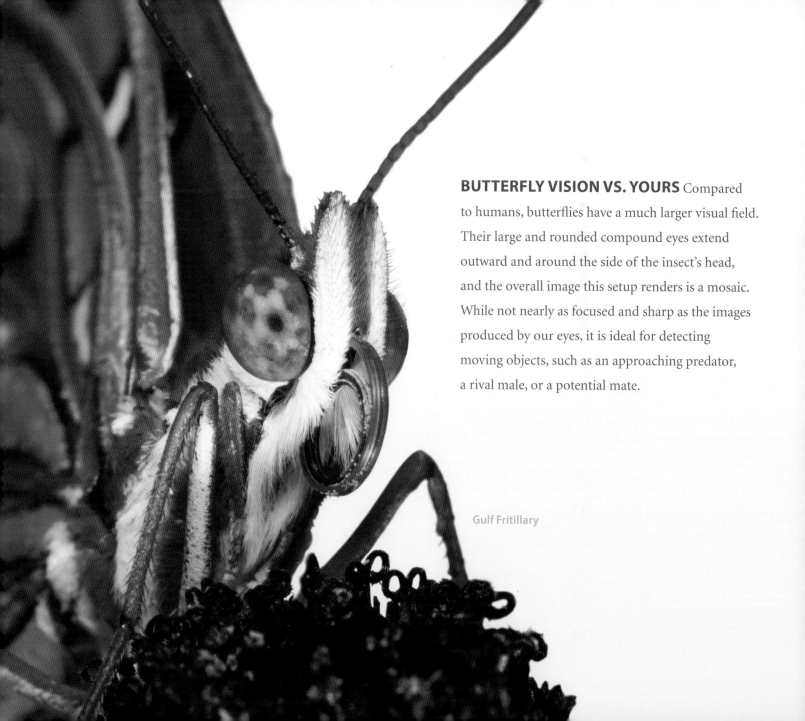

BUTTERFLY VISION VS. YOURS Compared to humans, butterflies have a much larger visual field. Their large and rounded compound eyes extend outward and around the side of the insect's head, and the overall image this setup renders is a mosaic. While not nearly as focused and sharp as the images produced by our eyes, it is ideal for detecting moving objects, such as an approaching predator, a rival male, or a potential mate.

Gulf Fritillary

TASTE Butterflies use their sense of taste to detect and assess food resources. Specifically, female butterflies have contact chemoreceptors on the tarsi, or feet, of their legs. When they physically land on a plant and scratch the leaf surface, the resulting mechanical disturbance releases chemical compounds. Based on the nature of these compounds, the female butterfly determines whether the plant is a suitable host for her offspring.

Other chemoreceptors are found on the outside of the proboscis and even inside the food canal. These detect sweet substances, such as sugars, helping the butterfly locate liquid food resources, and drink nectar.

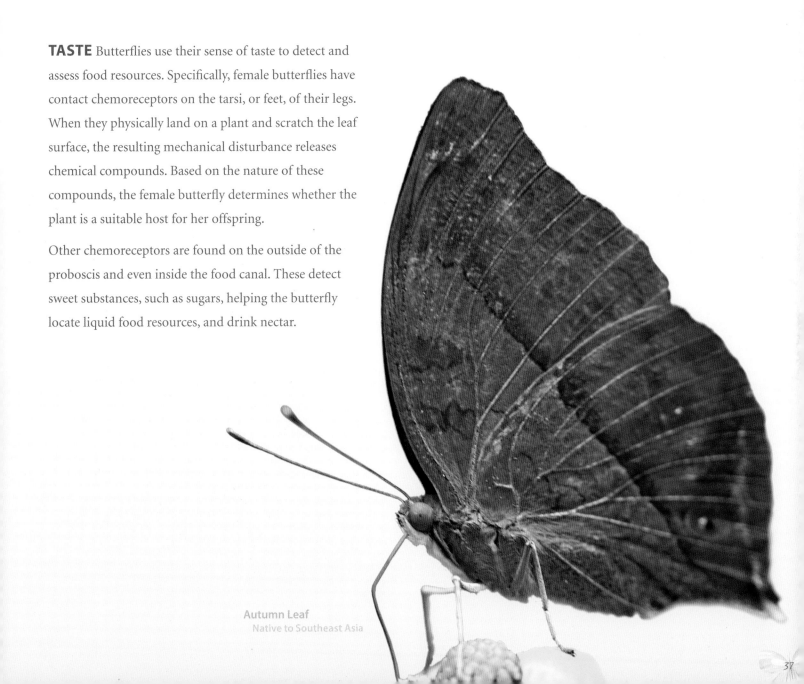

Autumn Leaf
Native to Southeast Asia

SMELL For a butterfly, scent can play an important role in foraging. While visually distinctive cues, such as color, help a butterfly locate flower nectar, scent is useful when finding other, less showy food sources. This includes fermenting fruit, animal dung, or carrion, which are more easily detected by smell. While the a butterfly's antennae have historically been thought to be the predominant organs used to smell, recent evidence has shown that additional chemoreceptors located on the legs, proboscis, and on structures on either side of the proboscis also respond to volatile compounds. Together, they may help to magnify the overall signal sent to the brain.

Tree Nymphs
Native to Southeast Asia

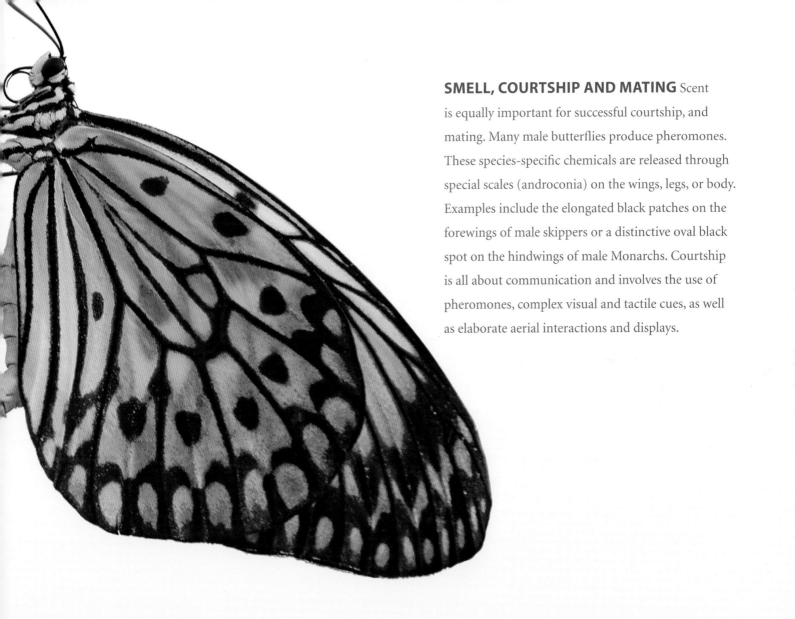

SMELL, COURTSHIP AND MATING Scent is equally important for successful courtship, and mating. Many male butterflies produce pheromones. These species-specific chemicals are released through special scales (androconia) on the wings, legs, or body. Examples include the elongated black patches on the forewings of male skippers or a distinctive oval black spot on the hindwings of male Monarchs. Courtship is all about communication and involves the use of pheromones, complex visual and tactile cues, as well as elaborate aerial interactions and displays.

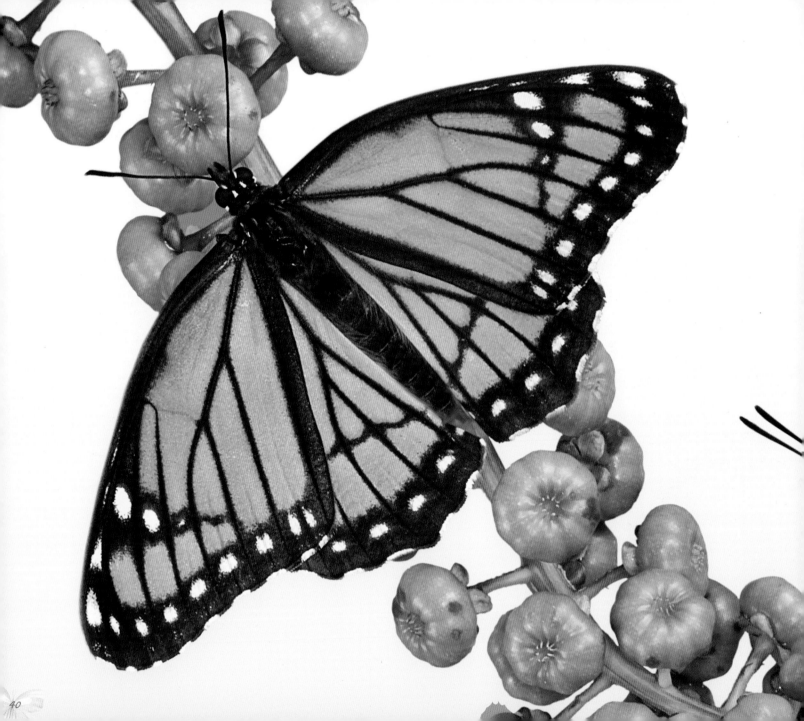

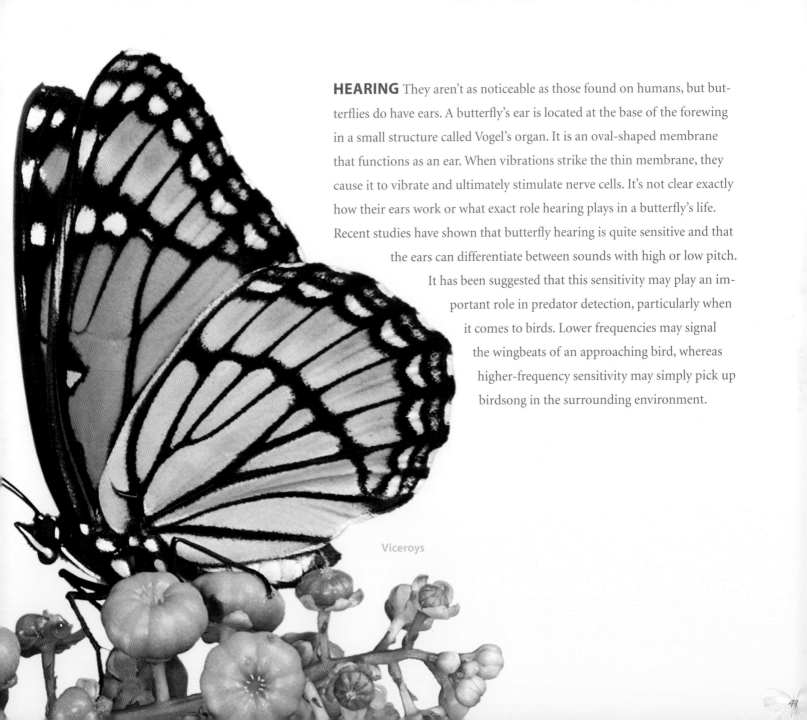

HEARING They aren't as noticeable as those found on humans, but butterflies do have ears. A butterfly's ear is located at the base of the forewing in a small structure called Vogel's organ. It is an oval-shaped membrane that functions as an ear. When vibrations strike the thin membrane, they cause it to vibrate and ultimately stimulate nerve cells. It's not clear exactly how their ears work or what exact role hearing plays in a butterfly's life. Recent studies have shown that butterfly hearing is quite sensitive and that the ears can differentiate between sounds with high or low pitch. It has been suggested that this sensitivity may play an important role in predator detection, particularly when it comes to birds. Lower frequencies may signal the wingbeats of an approaching bird, whereas higher-frequency sensitivity may simply pick up birdsong in the surrounding environment.

Viceroys

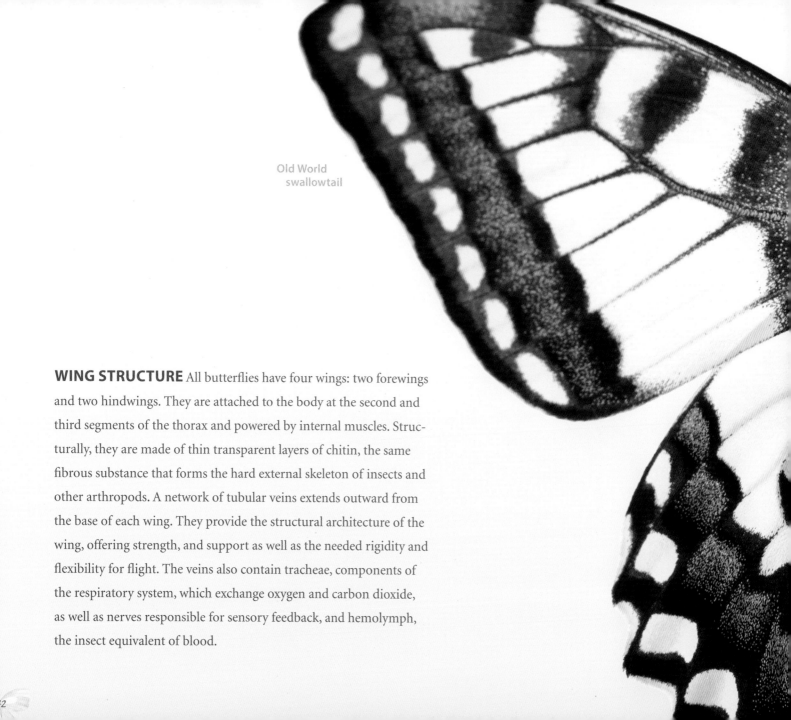

Old World
swallowtail

WING STRUCTURE All butterflies have four wings: two forewings
and two hindwings. They are attached to the body at the second and
third segments of the thorax and powered by internal muscles. Struc-
turally, they are made of thin transparent layers of chitin, the same
fibrous substance that forms the hard external skeleton of insects and
other arthropods. A network of tubular veins extends outward from
the base of each wing. They provide the structural architecture of the
wing, offering strength, and support as well as the needed rigidity and
flexibility for flight. The veins also contain tracheae, components of
the respiratory system, which exchange oxygen and carbon dioxide,
as well as nerves responsible for sensory feedback, and hemolymph,
the insect equivalent of blood.

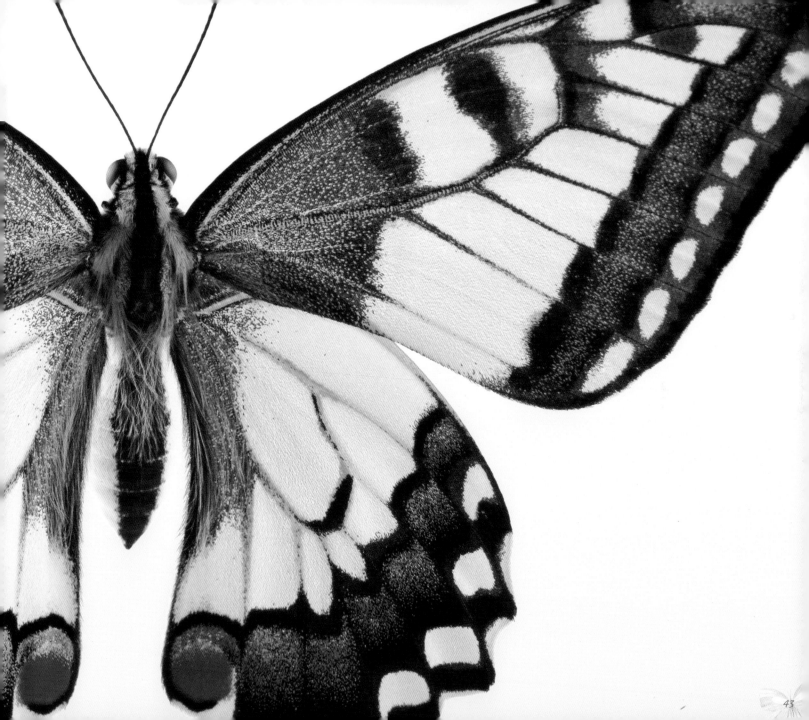

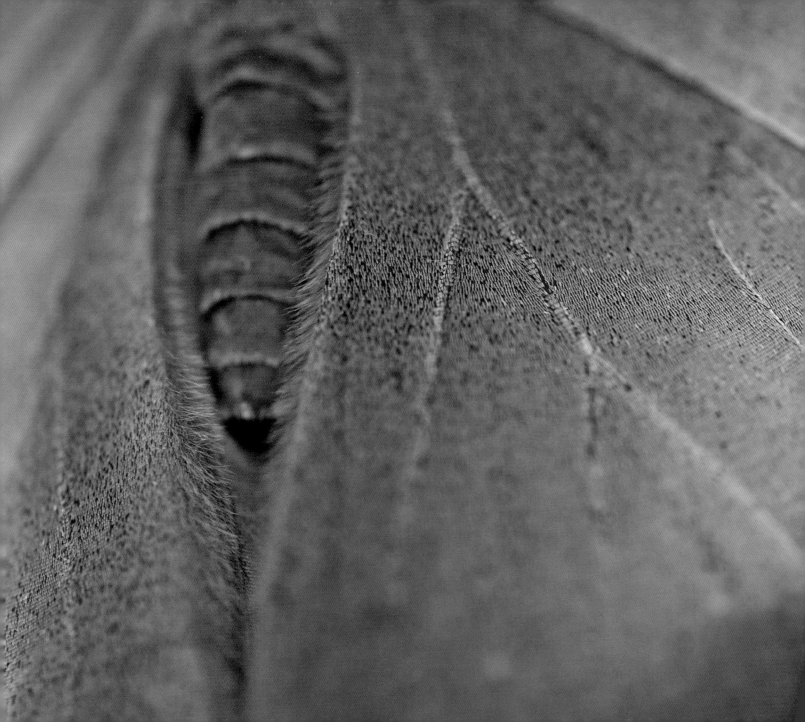

**Blue Morpho
Wing**

Incredible Scales A butterfly's wings are covered by thousands of tiny scales; these overlap like shingles on a roof. While they vary considerably in appearance, the scales that highlight a butterfly's colors are predominantly flat, plate-like structures attached to the wing variety by a narrow base. The exact orientation of these many scales creates the amazing myriad of wing colors and patterns for which butterflies are known. While each scale has a single distinctive color, they produce color by two fundamentally different means. Colors ranging from red, orange, and yellow to white, brown, and black are the result of pigments contained within the individual scales. By contrast, iridescent colors, such as green, blue, and purple, are produced by the complex microstructure of the scales themselves; this structure diffracts light, rendering brilliant metallic-like shades. Frequently a butterfly's color appears to vary depending on the wing angle and the observer's point of view.

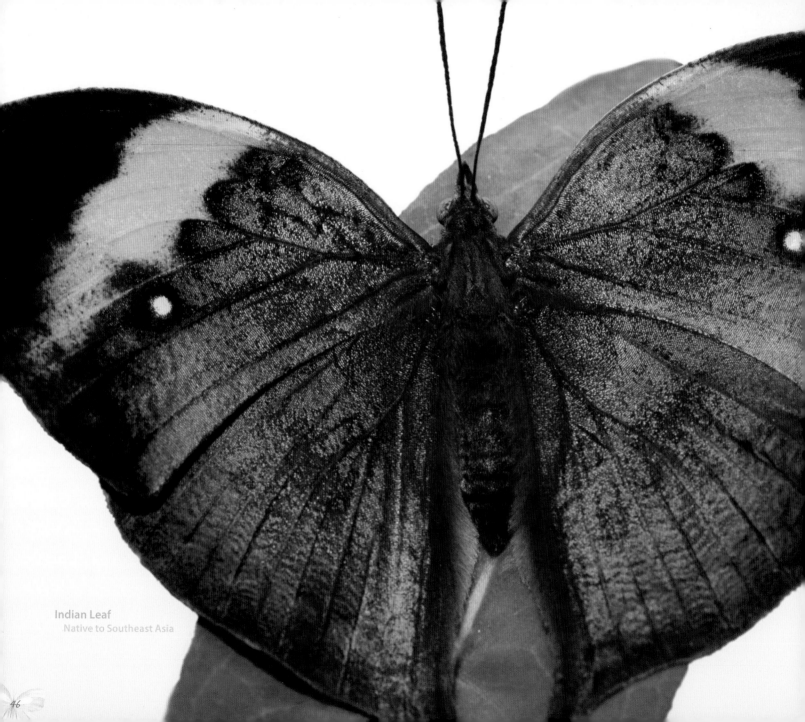

Indian Leaf
Native to Southeast Asia

46

The Role of Wings and Scales Insects were the first known animals to take to the air when they developed wings some 400 million years ago. The evolutionary origin of insect flight, however, has traditionally perplexed scientists and been the subject of much debate and uncertainty. Recent compelling evidence suggests that insect wings evolved from gill-like appendages found in the aquatic ancestors of modern-day arthropods. The development of flight made insects more mobile, in turn providing them with access to new habitats and the opportunity to exploit new resources, leading to a massive boom in insect diversity. The rest is history. Over the following millions of years, flight helped insects to become the most diverse and successful group of organisms on the planet. Although dwarfed by the numbers of species in several other insect groups, such as beetles, some 18,000 butterfly species are found worldwide.

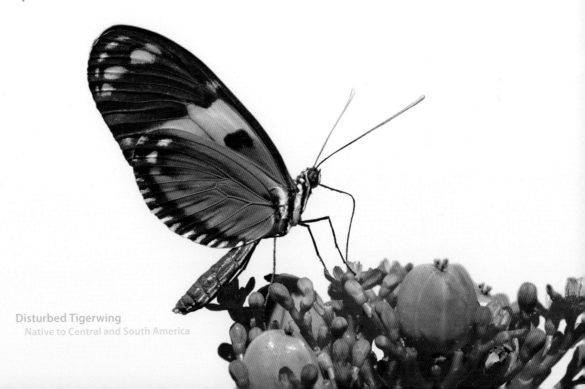

Disturbed Tigerwing
Native to Central and South America

More Than Window Dressing More than just a beautiful mosaic, the scales covering a butterfly's wings are important for survival, as they are involved in flight, temperature regulation, and even reproduction. Scale arrangement enhances a butterfly's aerodynamics, especially lift and thrust, and reduces overall drag when flying or gliding. Scales are additionally important for insulation and thermoregulation. As most butterflies require elevated body temperatures in order to fly, the dark scale colors (produced by melanin) help the wings absorb solar radiation and conduct heat to the thorax.

Many Different Adaptations The tremendous variety and complexity seen in butterfly wing colors and patterns is the result of many evolutionary adaptations over time. Some wing colors and patterns make the perfect camouflage, while others are veritable calling cards, helping butterflies recognize their own species (and potential mates). Still other adaptations help butterfly species advertise their distastefulness to potential predators or enable them to mimic more-threatening creatures. Beyond color, some highly modified wing scales are even involved in courtship. Known as androconia, these scales are found in males and release pheromones during courtship. Dense clusters of these scales often form a distinct dark patch on the wing.

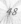

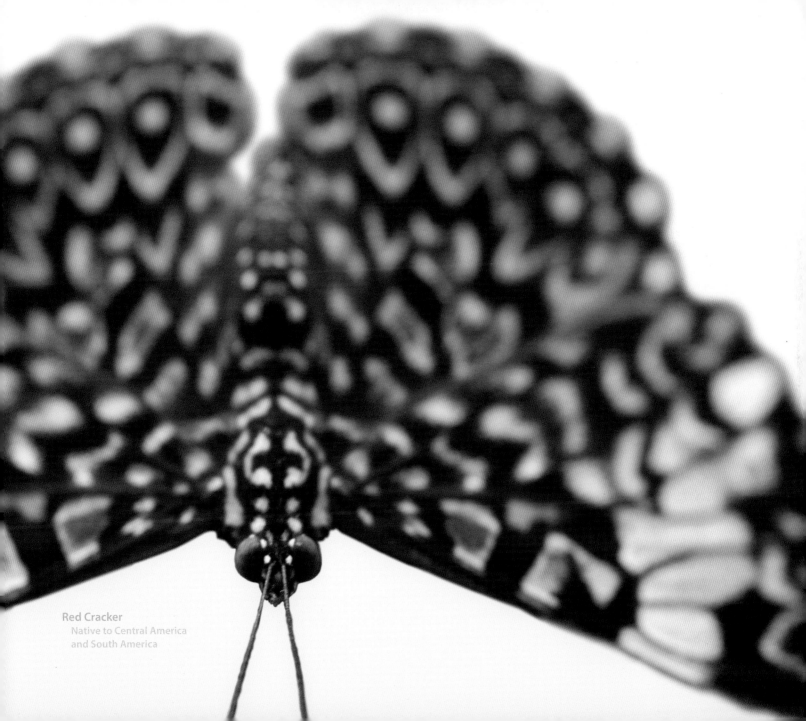

Red Cracker
Native to Central America
and South America

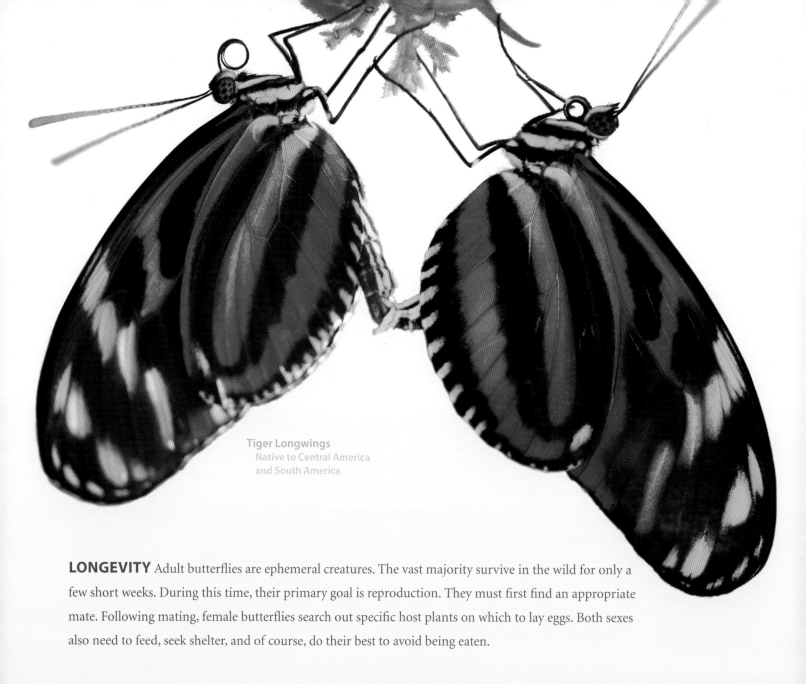

Tiger Longwings
Native to Central America
and South America

LONGEVITY Adult butterflies are ephemeral creatures. The vast majority survive in the wild for only a few short weeks. During this time, their primary goal is reproduction. They must first find an appropriate mate. Following mating, female butterflies search out specific host plants on which to lay eggs. Both sexes also need to feed, seek shelter, and of course, do their best to avoid being eaten.

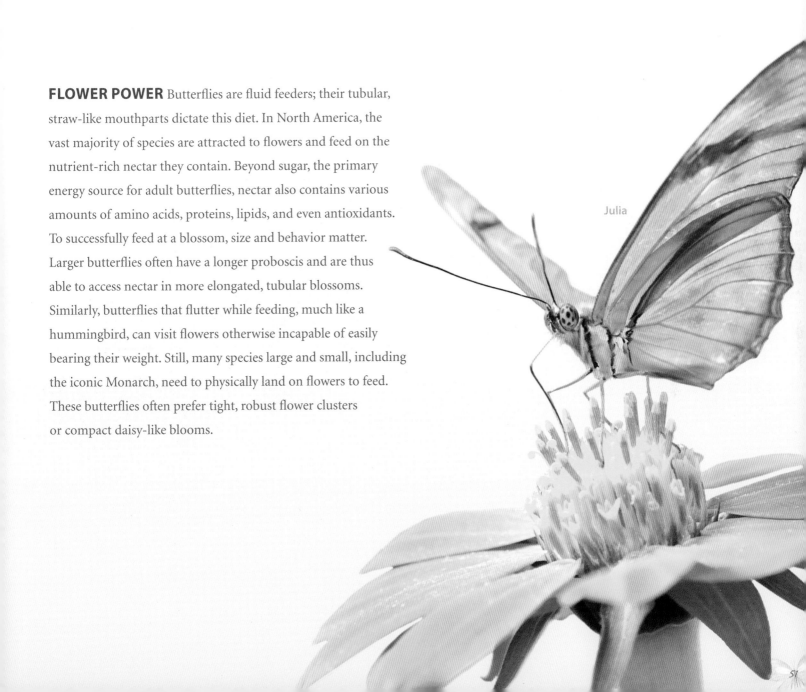

FLOWER POWER Butterflies are fluid feeders; their tubular, straw-like mouthparts dictate this diet. In North America, the vast majority of species are attracted to flowers and feed on the nutrient-rich nectar they contain. Beyond sugar, the primary energy source for adult butterflies, nectar also contains various amounts of amino acids, proteins, lipids, and even antioxidants. To successfully feed at a blossom, size and behavior matter. Larger butterflies often have a longer proboscis and are thus able to access nectar in more elongated, tubular blossoms. Similarly, butterflies that flutter while feeding, much like a hummingbird, can visit flowers otherwise incapable of easily bearing their weight. Still, many species large and small, including the iconic Monarch, need to physically land on flowers to feed. These butterflies often prefer tight, robust flower clusters or compact daisy-like blooms.

Julia

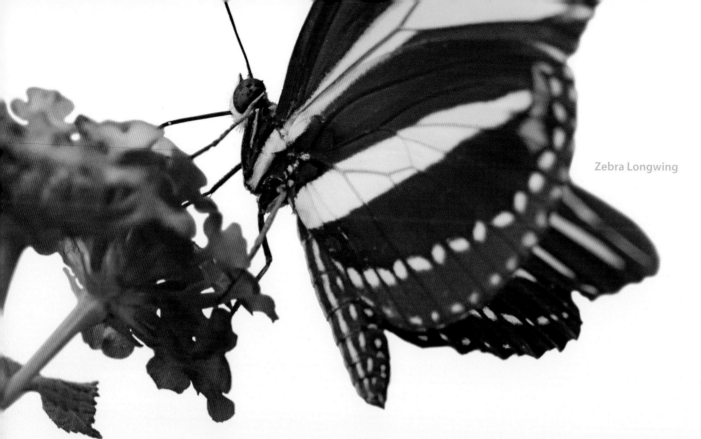

Zebra Longwing

Collecting Pollen: A Rarity Although all butterflies that visit flowers frequently come in contact with pollen, only one North American species actively collects it for food. The Zebra Longwing is Florida's state butterfly and a member of the diverse neotropical genus *Heliconius*. These distinctive longwing butterflies gather pollen grains one by one on their proboscis, amass them into a larger ball, and then produce specialized saliva containing digestive enzymes. The enzymes break the pollen down into a liquid rich in amino acids and protein, which is readily consumed by the adults. This beneficial nutrition supplements a traditional nectar diet and has a profound impact on adult longevity and reproduction. Longwing adults can survive for many months, significantly longer than most other butterflies, and continuously lay eggs at a steady rate over the course of their lives.

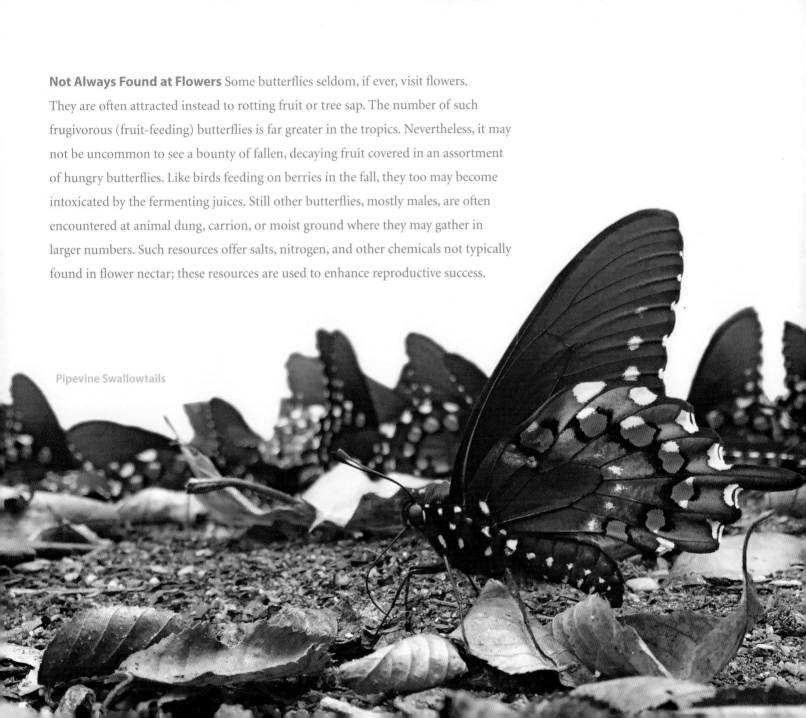

Not Always Found at Flowers Some butterflies seldom, if ever, visit flowers. They are often attracted instead to rotting fruit or tree sap. The number of such frugivorous (fruit-feeding) butterflies is far greater in the tropics. Nevertheless, it may not be uncommon to see a bounty of fallen, decaying fruit covered in an assortment of hungry butterflies. Like birds feeding on berries in the fall, they too may become intoxicated by the fermenting juices. Still other butterflies, mostly males, are often encountered at animal dung, carrion, or moist ground where they may gather in larger numbers. Such resources offer salts, nitrogen, and other chemicals not typically found in flower nectar; these resources are used to enhance reproductive success.

Pipevine Swallowtails

MIMICRY Butterflies showcase some of the most striking examples of mimicry in the natural world. Unpalatable butterfly species often advertise their appearance with bold colors and distinctive patterns. This is called aposematism. Other species, in turn mimic those species to deceive would-be predators, such as birds, which hunt primarily by using vision. What's more, noxious butterfly species can also mimic similar-looking noxious butterfly species, as this compounds the visual effect. Mimicry may only involve "a handful of species, or an entire interrelated web of species. Mimicry is most common and well developed in the tropics, where butterfly diversity is highest, but it is found in North America as well.

Eastern Tiger Swallowtail

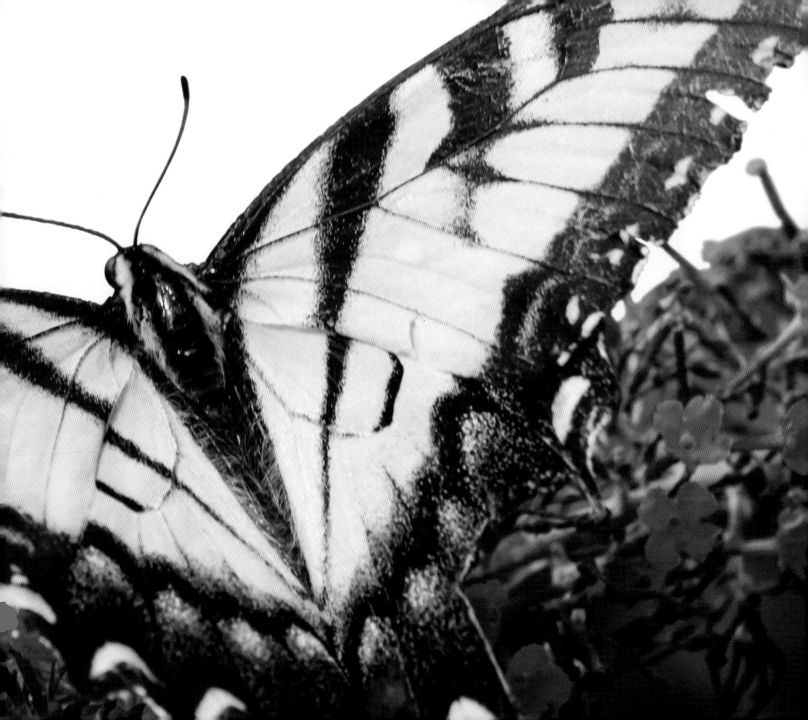

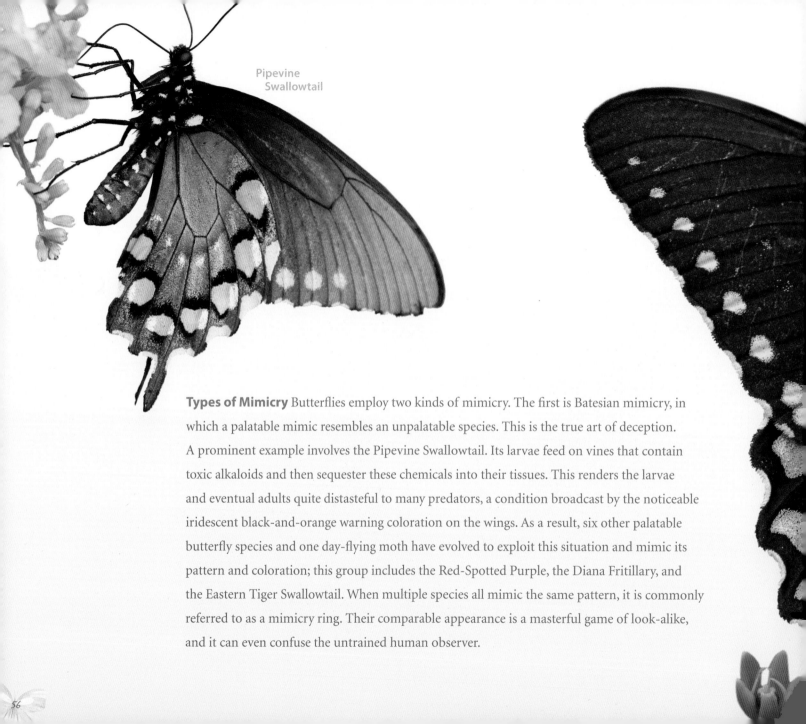

Pipevine
Swallowtail

Types of Mimicry Butterflies employ two kinds of mimicry. The first is Batesian mimicry, in which a palatable mimic resembles an unpalatable species. This is the true art of deception. A prominent example involves the Pipevine Swallowtail. Its larvae feed on vines that contain toxic alkaloids and then sequester these chemicals into their tissues. This renders the larvae and eventual adults quite distasteful to many predators, a condition broadcast by the noticeable iridescent black-and-orange warning coloration on the wings. As a result, six other palatable butterfly species and one day-flying moth have evolved to exploit this situation and mimic its pattern and coloration; this group includes the Red-Spotted Purple, the Diana Fritillary, and the Eastern Tiger Swallowtail. When multiple species all mimic the same pattern, it is commonly referred to as a mimicry ring. Their comparable appearance is a masterful game of look-alike, and it can even confuse the untrained human observer.

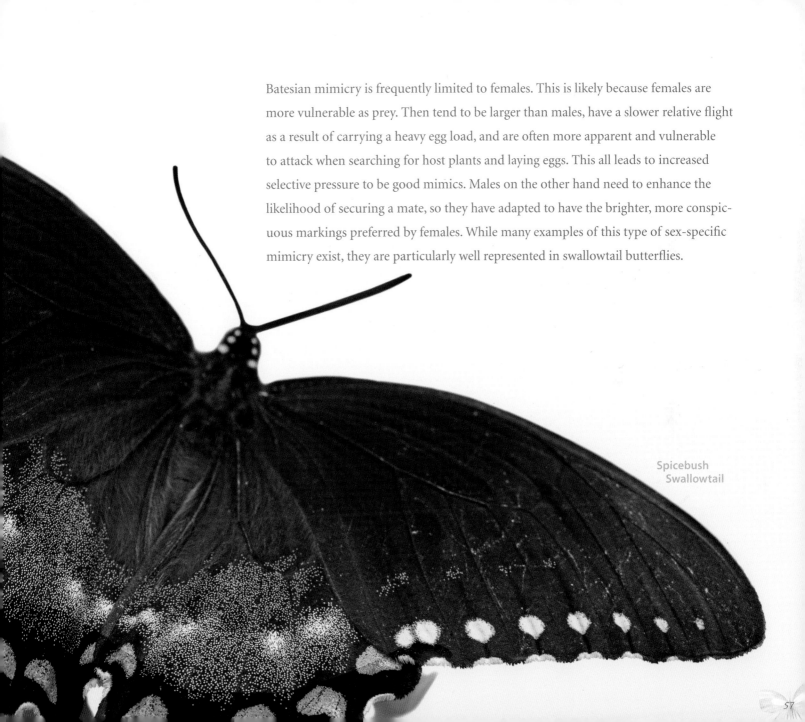

Batesian mimicry is frequently limited to females. This is likely because females are more vulnerable as prey. Then tend to be larger than males, have a slower relative flight as a result of carrying a heavy egg load, and are often more apparent and vulnerable to attack when searching for host plants and laying eggs. This all leads to increased selective pressure to be good mimics. Males on the other hand need to enhance the likelihood of securing a mate, so they have adapted to have the brighter, more conspicuous markings preferred by females. While many examples of this type of sex-specific mimicry exist, they are particularly well represented in swallowtail butterflies.

Spicebush
Swallowtail

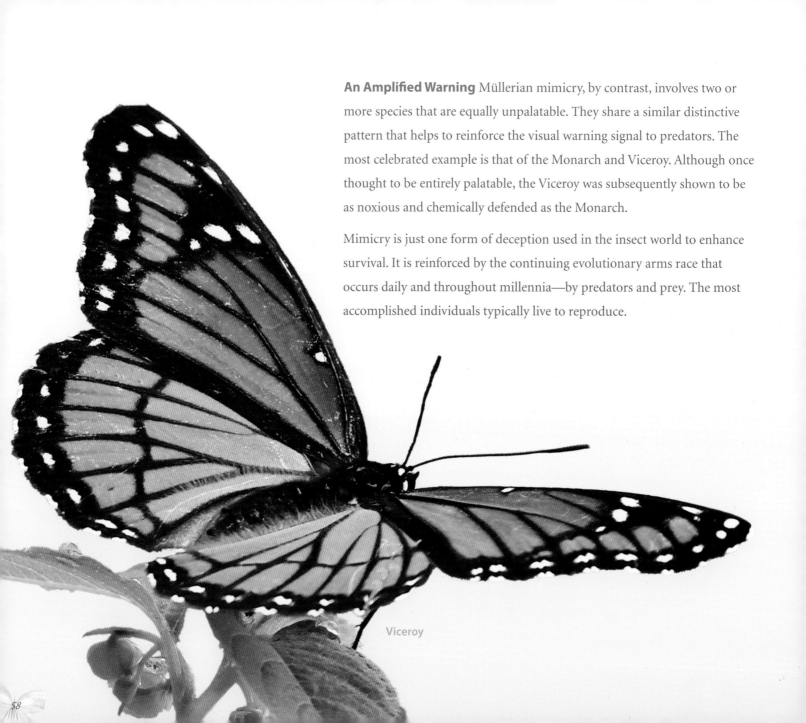

An Amplified Warning Müllerian mimicry, by contrast, involves two or more species that are equally unpalatable. They share a similar distinctive pattern that helps to reinforce the visual warning signal to predators. The most celebrated example is that of the Monarch and Viceroy. Although once thought to be entirely palatable, the Viceroy was subsequently shown to be as noxious and chemically defended as the Monarch.

Mimicry is just one form of deception used in the insect world to enhance survival. It is reinforced by the continuing evolutionary arms race that occurs daily and throughout millennia—by predators and prey. The most accomplished individuals typically live to reproduce.

Viceroy

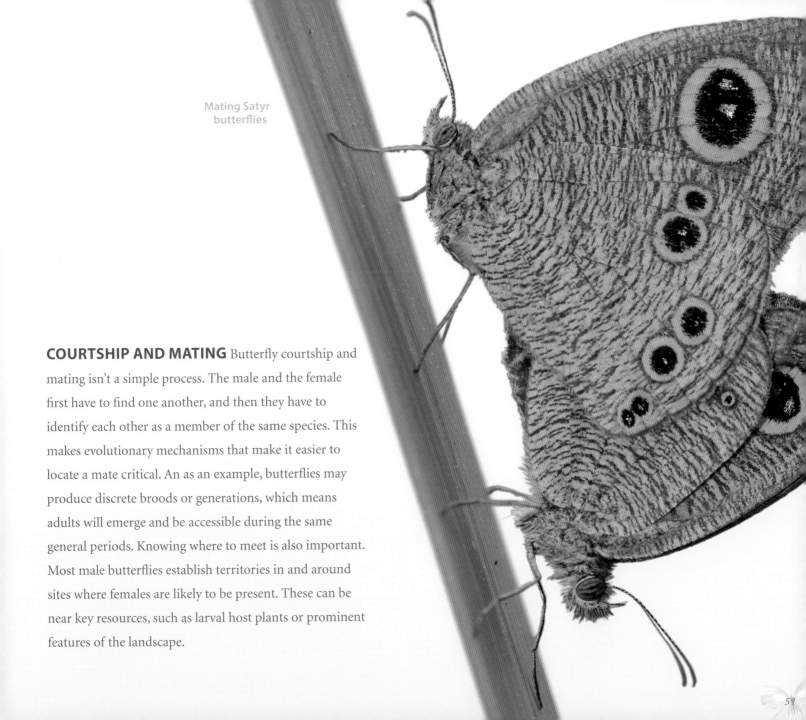

Mating Satyr
butterflies

COURTSHIP AND MATING Butterfly courtship and mating isn't a simple process. The male and the female first have to find one another, and then they have to identify each other as a member of the same species. This makes evolutionary mechanisms that make it easier to locate a mate critical. An as an example, butterflies may produce discrete broods or generations, which means adults will emerge and be accessible during the same general periods. Knowing where to meet is also important. Most male butterflies establish territories in and around sites where females are likely to be present. These can be near key resources, such as larval host plants or prominent features of the landscape.

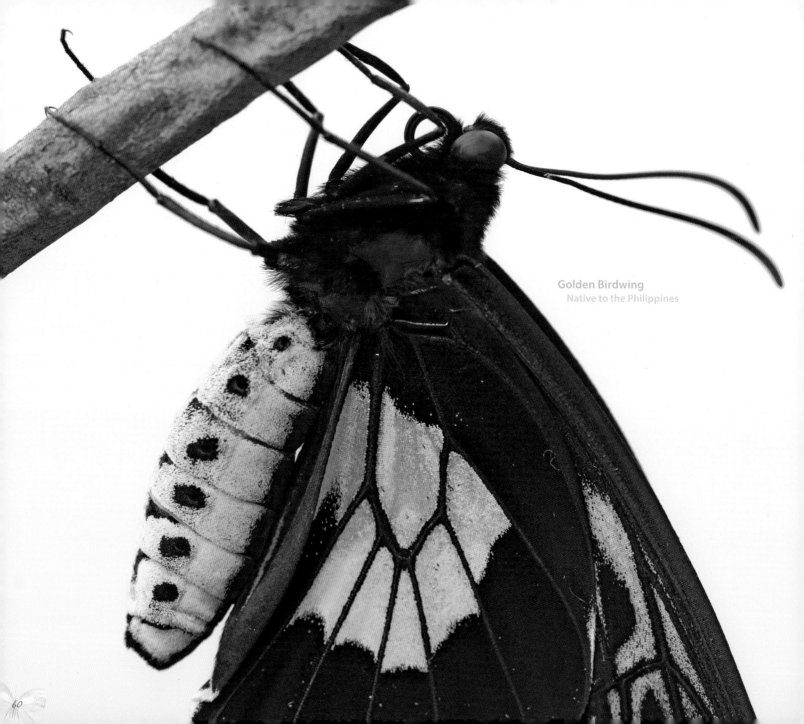

Golden Birdwing
Native to the Philippines

60

Defending Territory Males of some species perch along trails, on overhanging branches, or even on the ground and wait for passing females. They will often fly out to investigate any nearby butterflies or other insects before returning to the same general location. They will also aggressively defend their territory from other rival males. This intense competition often involves prolonged aerial battles until one male is victorious and the other leaves the territory. Males of other species may patrol a given territory in search of females. They might traverse an open field or fly back and forth along a hilltop. In all cases, the goal of perching or patrolling is the same—to find a mate before another male does.

Long-Range Efforts Males use long-range visual cues to locate potential mates. Once a female is spotted and approached, mate selection is largely driven by chemical signals and involves species-specific pheromones at close range. These chemical cues, combined with other behavioral and tactile stimuli, provide information that lead the female to either accept or reject the male's advances.

If the female consents, mating takes place. Most pairs remain together for several minutes to over an hour. This is a dangerous time for butterflies, and they must try to avoid detection by predators. They often rest on vegetation and remain motionless. If disturbed, they can fly away, with one butterfly carrying the other, but they generally do not travel far before alighting again.

MIGRATION Although several species of butterflies migrate, the Monarch is arguably the most well-known migrator. Its migration is considered one of the most spectacular natural phenomena on the planet. No other butterfly makes such a long-distance, two-way flight every year. Hundreds of millions of monarchs are involved, with some traveling over 3,000 miles.

Butterflies migrate to avoid unfavorable conditions. This might mean escaping freezing temperatures or locating needed food resources. The monarch essentially does both. During spring and summer, monarchs breed throughout the U.S. and southern Canada. As fall approaches, cooler temperatures, shorter days, and decreasing host plant quality trigger physiological changes in emerging adults. This is known as reproductive diapause, and during this period they do not mate or lay eggs. Instead, they feed, building up energy reserves, and then begin migrating.

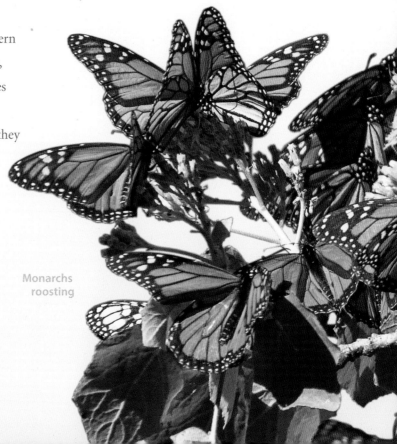

Monarchs roosting

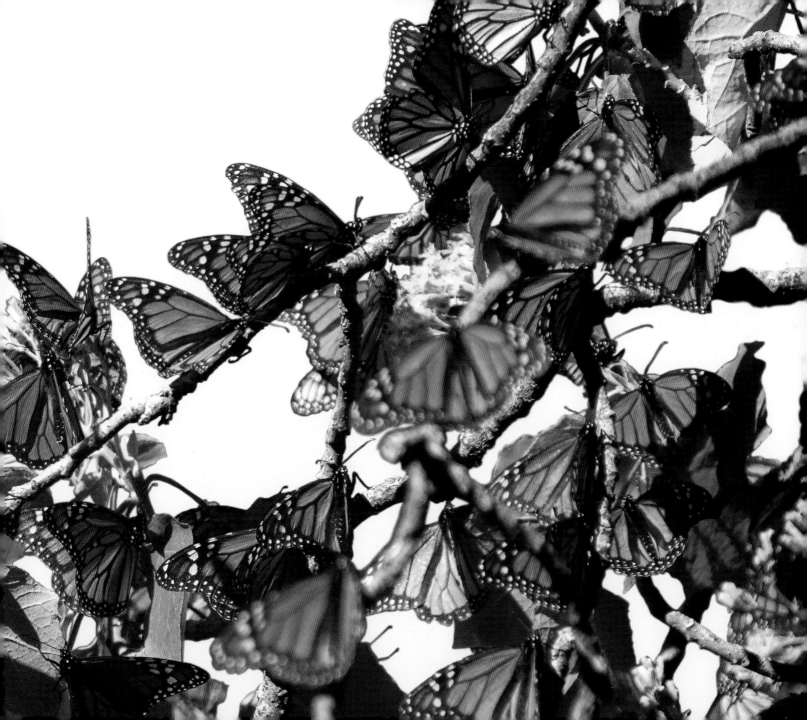

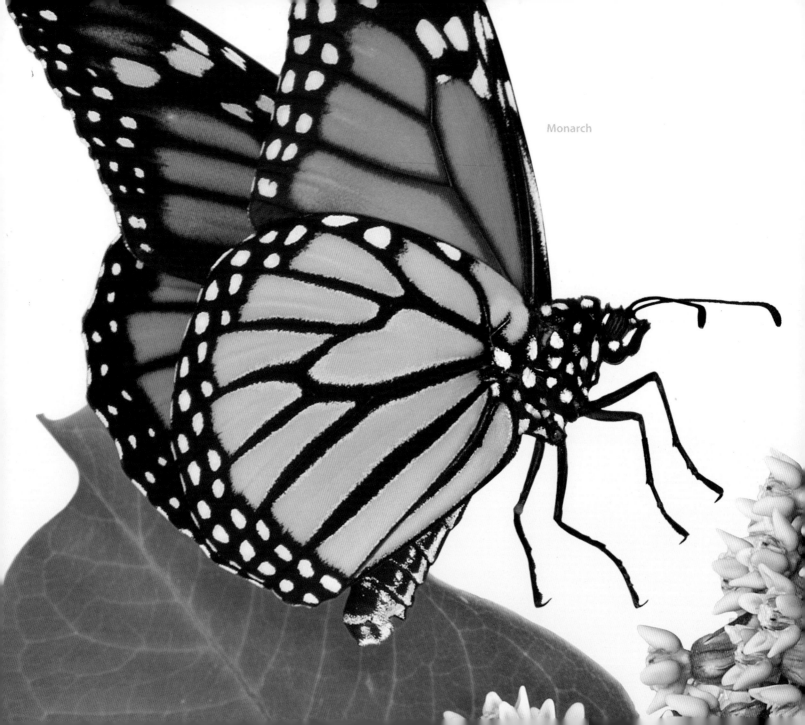

Monarch

An Incredible Journey Monarchs east of the Rocky Mountains fly to high-elevation fir forests in Mexico to overwinter. In the western U.S., they travel to scattered groves along the coast of California. Wherever they travel, the following spring the butterflies mate, leave their overwintering sites, and fly northward or inland in search of milkweed on which to lay their eggs. As Monarchs move north across North America, they follow the progression of spring, and produce several generations along the way. The same process in repeated every year. In South Florida, some non-migratory individuals remain and breed year-round. It is the only location with a continuous resident population.

Butterfly Families

There are six major families of butterflies, many of which have sub-families. The major families are the **Swallowtails and Parnassians** (Papilionidae), the **Whites, Sulphurs, and Yellows** (Pieridae), the **Coppers, Blues, Hairstreaks, and Harvesters** (Lycaenidae), the **Brush-footed Butterflies** (Nymphalidae), the **Metalmarks** (Riodinidae), and the **Skippers** (Hesperiidae).

While all butterfly families are closely related to each other, the members of each family have various physical characteristics that scientists have used to categorize them. Modern genetic research has further helped to clarify and often refine these relationships.

Red-spotted
Purples

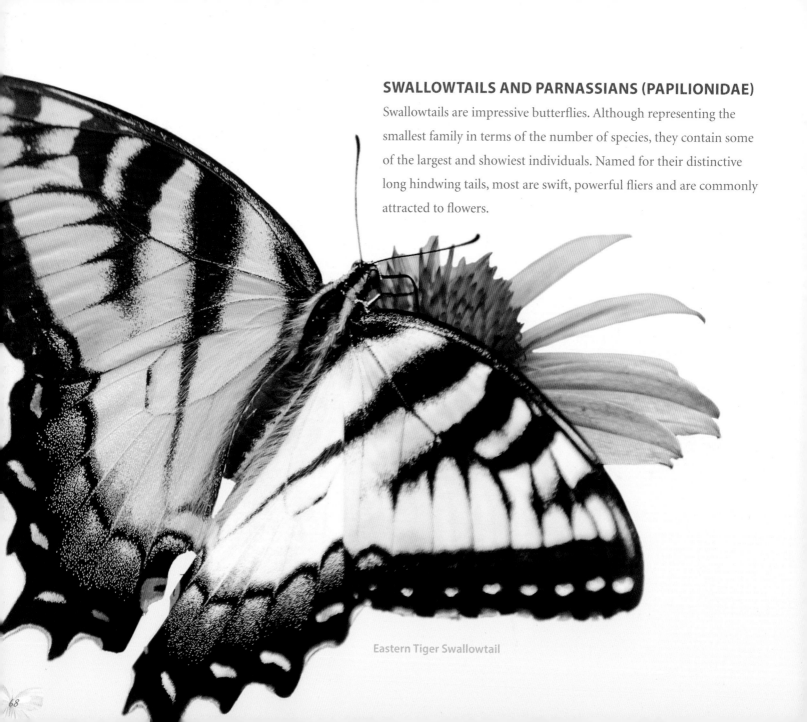

SWALLOWTAILS AND PARNASSIANS (PAPILIONIDAE)

Swallowtails are impressive butterflies. Although representing the smallest family in terms of the number of species, they contain some of the largest and showiest individuals. Named for their distinctive long hindwing tails, most are swift, powerful fliers and are commonly attracted to flowers.

Eastern Tiger Swallowtail

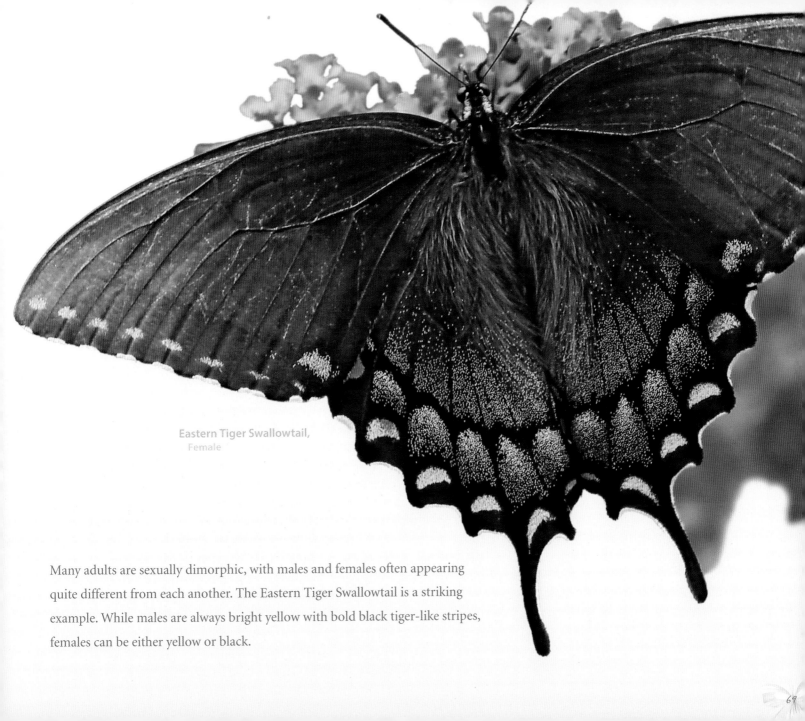

Eastern Tiger Swallowtail,
Female

Many adults are sexually dimorphic, with males and females often appearing quite different from each another. The Eastern Tiger Swallowtail is a striking example. While males are always bright yellow with bold black tiger-like stripes, females can be either yellow or black.

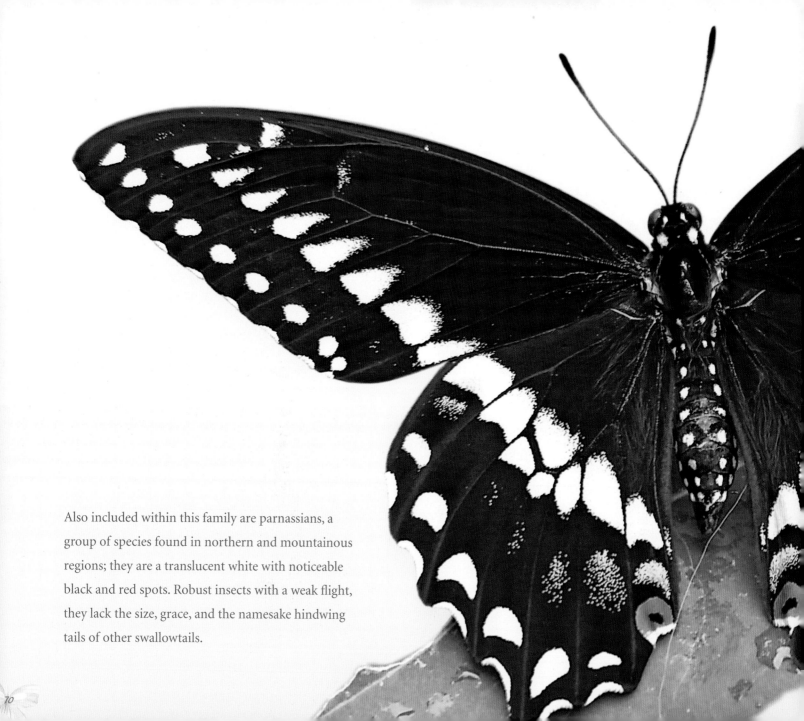

Also included within this family are parnassians, a group of species found in northern and mountainous regions; they are a translucent white with noticeable black and red spots. Robust insects with a weak flight, they lack the size, grace, and the namesake hindwing tails of other swallowtails.

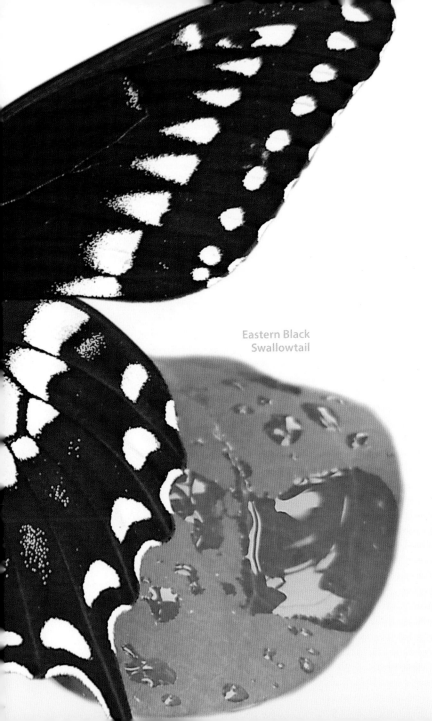

Eastern Black
Swallowtail

A Conservation Icon The Schaus Swallowtail is a large,
iconic butterfly and the first insect to gain protection
under the Endangered Species Act. Inhabiting dense
upland forests called tropical hardwood hammocks, it is
now restricted to only a few small islands in the northern
Florida Keys, making it one of the rarest butterflies in the
U.S. and our only federally listed swallowtail.

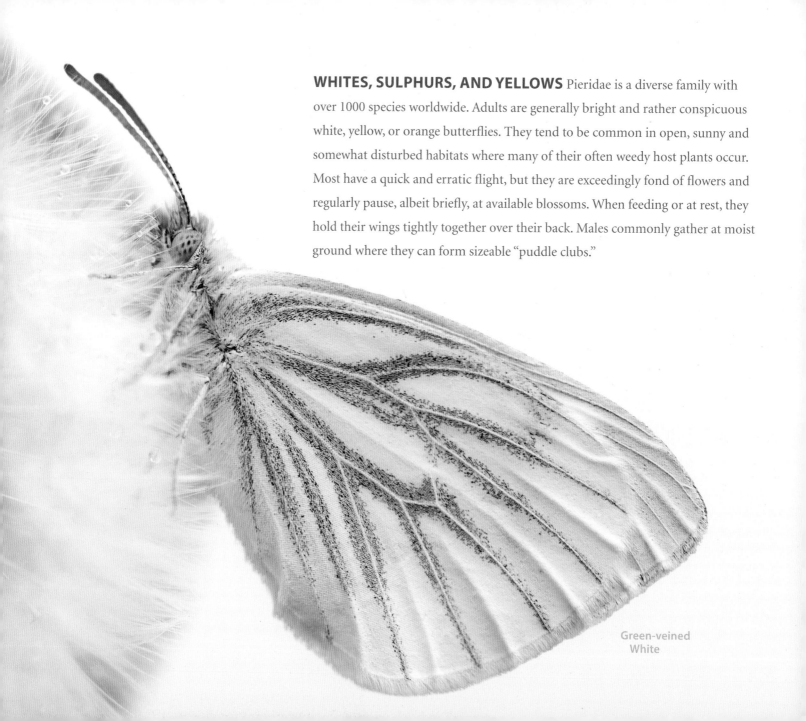

WHITES, SULPHURS, AND YELLOWS Pieridae is a diverse family with over 1000 species worldwide. Adults are generally bright and rather conspicuous white, yellow, or orange butterflies. They tend to be common in open, sunny and somewhat disturbed habitats where many of their often weedy host plants occur. Most have a quick and erratic flight, but they are exceedingly fond of flowers and regularly pause, albeit briefly, at available blossoms. When feeding or at rest, they hold their wings tightly together over their back. Males commonly gather at moist ground where they can form sizeable "puddle clubs."

Green-veined White

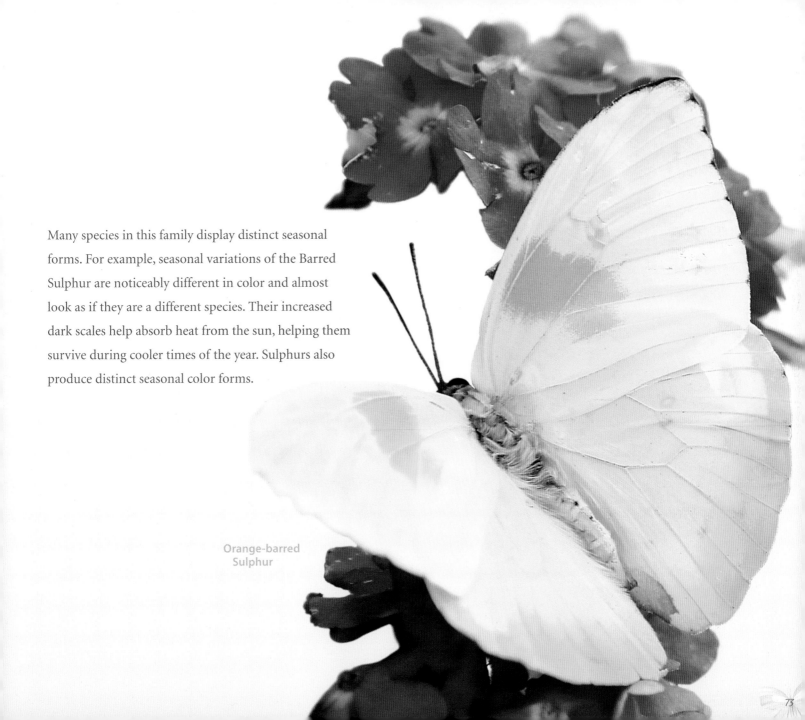

Many species in this family display distinct seasonal forms. For example, seasonal variations of the Barred Sulphur are noticeably different in color and almost look as if they are a different species. Their increased dark scales help absorb heat from the sun, helping them survive during cooler times of the year. Sulphurs also produce distinct seasonal color forms.

Orange-barred
Sulphur

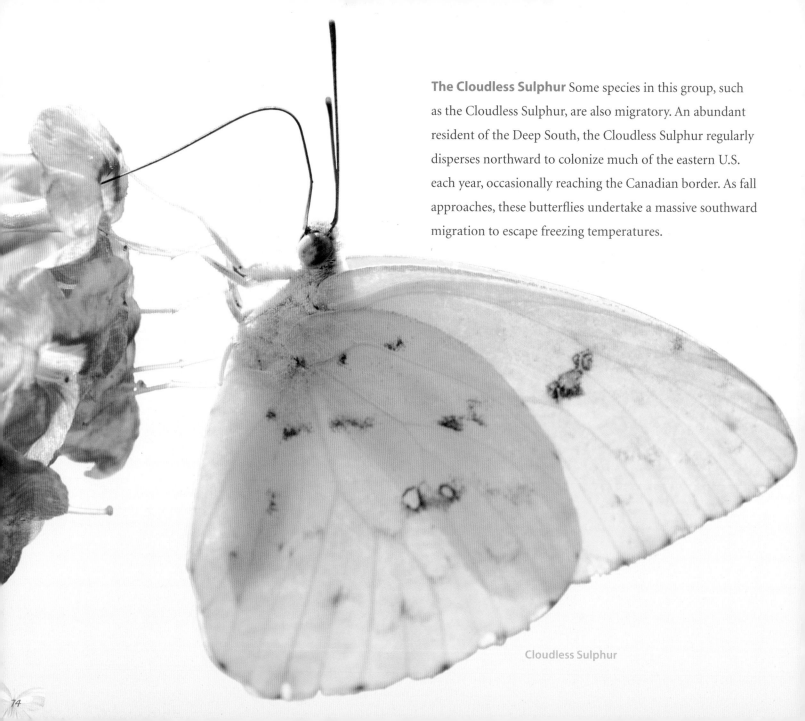

The Cloudless Sulphur Some species in this group, such as the Cloudless Sulphur, are also migratory. An abundant resident of the Deep South, the Cloudless Sulphur regularly disperses northward to colonize much of the eastern U.S. each year, occasionally reaching the Canadian border. As fall approaches, these butterflies undertake a massive southward migration to escape freezing temperatures.

Cloudless Sulphur

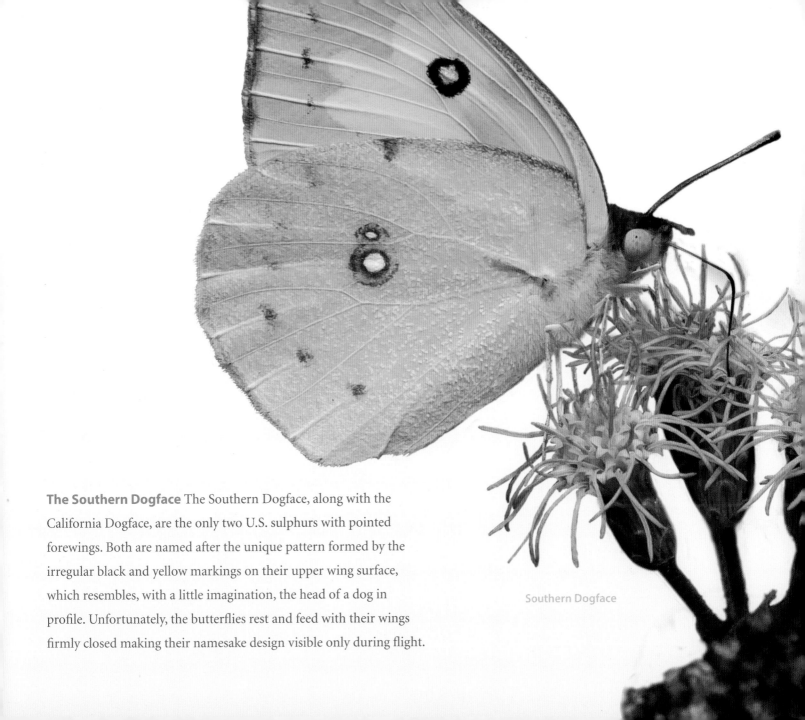

The Southern Dogface The Southern Dogface, along with the California Dogface, are the only two U.S. sulphurs with pointed forewings. Both are named after the unique pattern formed by the irregular black and yellow markings on their upper wing surface, which resembles, with a little imagination, the head of a dog in profile. Unfortunately, the butterflies rest and feed with their wings firmly closed making their namesake design visible only during flight.

Southern Dogface

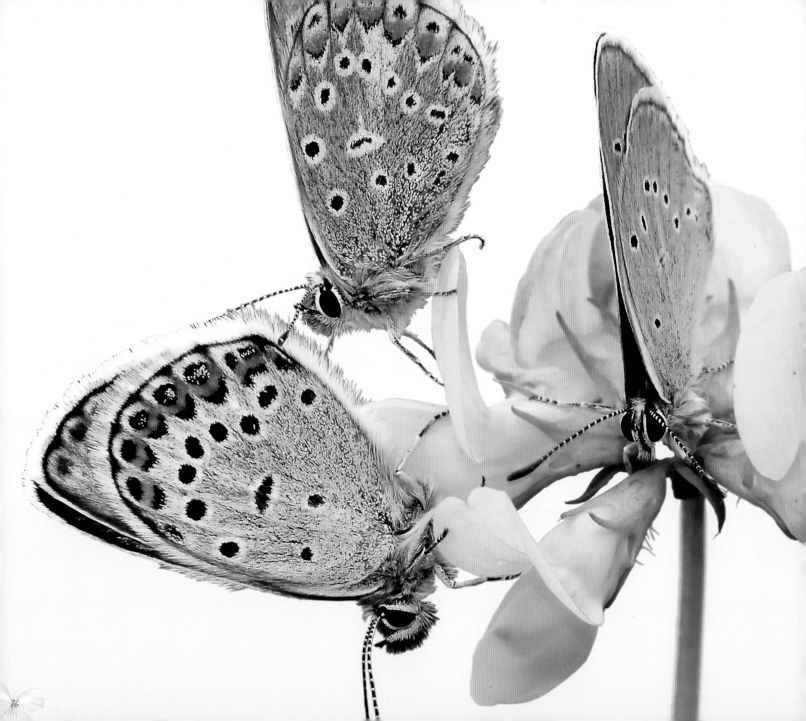

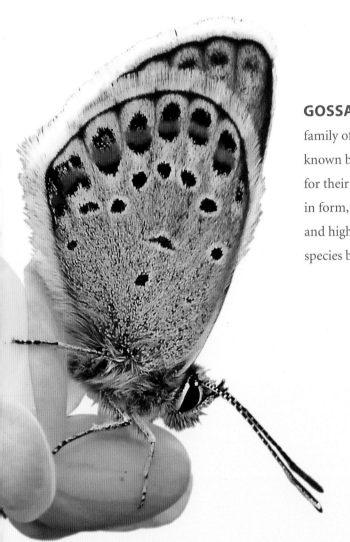

GOSSAMER WINGS (LYCAENIDAE) Representing the second-largest family of butterflies, the Gossamer family contains a wide variety of well-known butterflies, including blues, coppers, hairstreaks, and harvesters. Named for their delicate appearance, individuals are small in size but incredibly diverse in form, habitat association, and behavior. Many species are very specialized and highly local in occurrence. As a result, they are often quite rare with ten species being listed by the U.S. as federally threatened or endangered.

Blues on a flower

American Copper

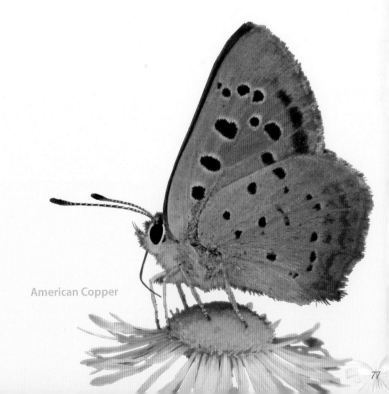

Coppers While coppers are widespread in temperate regions, several species are in decline. As their name suggests, adults are brilliantly colored with metallic tones of orange, blue, or purple. They regularly visit flowers or perch on low vegetation with their wings partially open. When seen in full sun, their markings are particularly radiant.

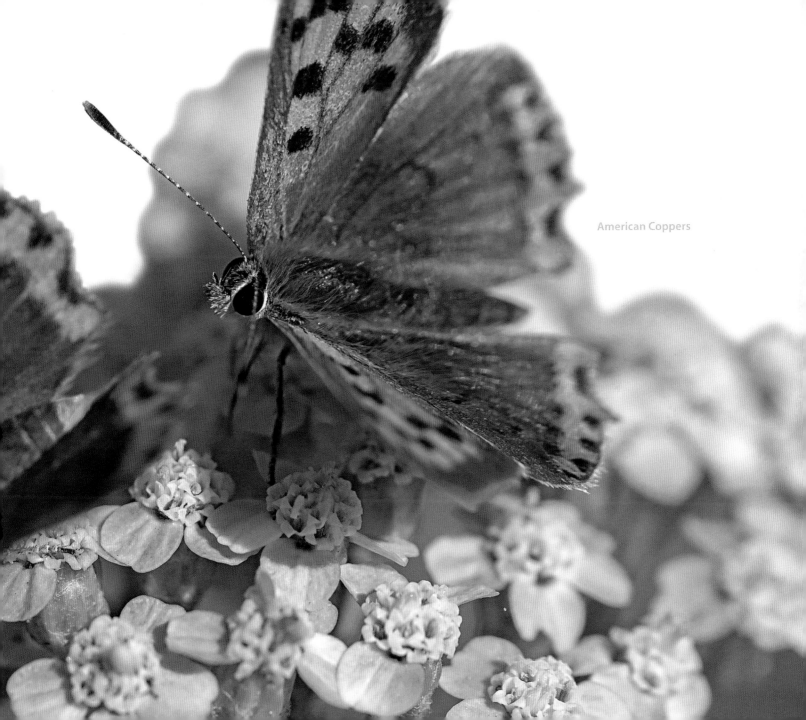

American Coppers

Blues Blues are the smallest butterflies. Most are about the size of a nickel. They are blue or gray in color and sexually dimorphic (males and females look different). Hairstreaks are similar, but generally a bit larger. Their hindwings also tend to be ornately patterned and showcase one or more fine, hair-like tails. Many blues and hairstreaks have close associations with ants. While generally mutualistic, the relationships can also be predatory or parasitic in a few species. Usually, the butterfly larvae produce secretions or chemicals that appease, attract, or reward their ant companions. In return, the ants regularly tend, and protect the growing larvae from various roaming predators. Some species even require the presence of a particular ant to complete development.

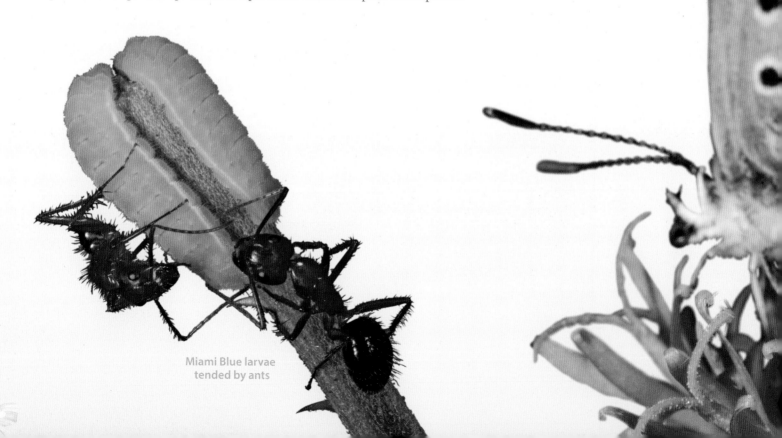

Miami Blue larvae
tended by ants

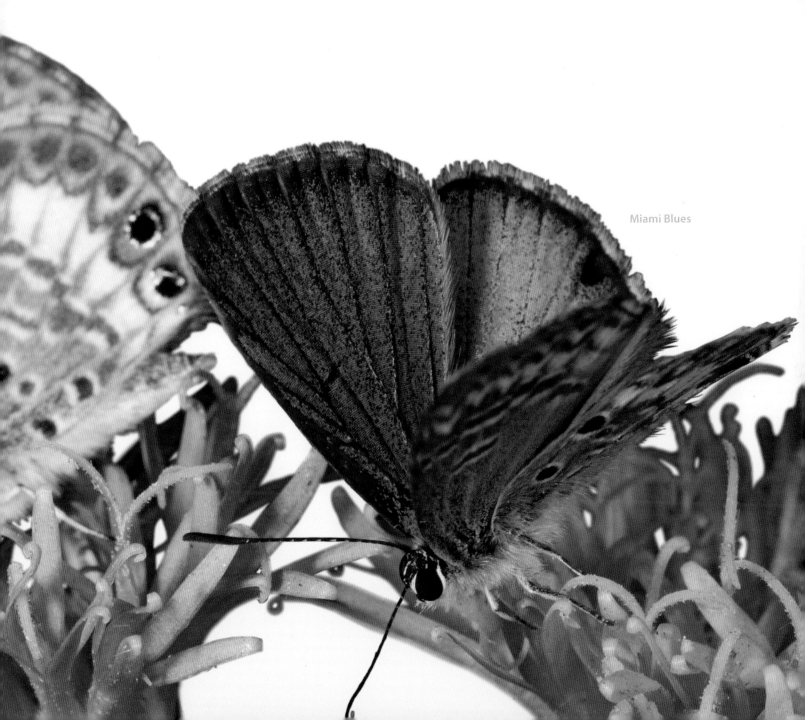

Miami Blues

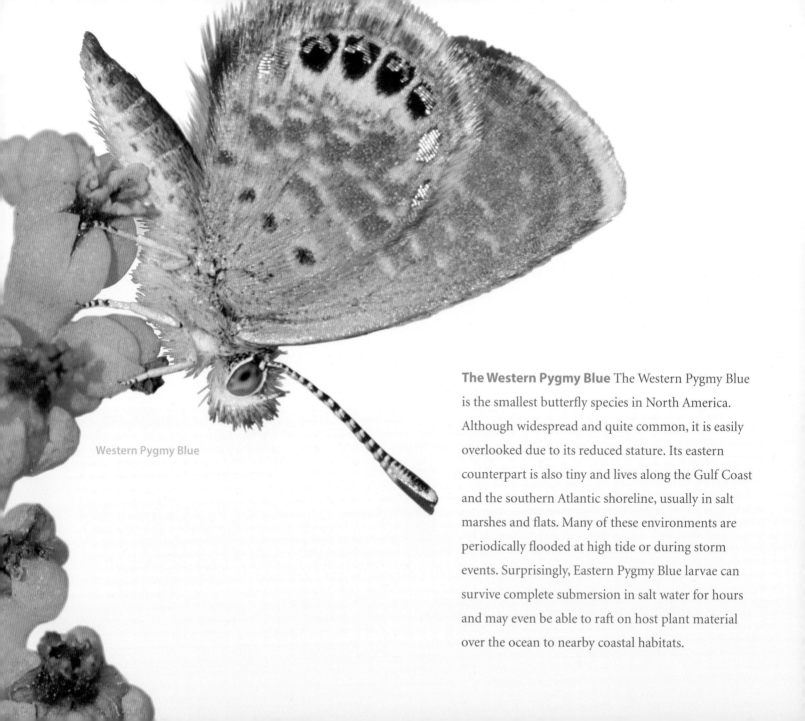

Western Pygmy Blue

The Western Pygmy Blue The Western Pygmy Blue is the smallest butterfly species in North America. Although widespread and quite common, it is easily overlooked due to its reduced stature. Its eastern counterpart is also tiny and lives along the Gulf Coast and the southern Atlantic shoreline, usually in salt marshes and flats. Many of these environments are periodically flooded at high tide or during storm events. Surprisingly, Eastern Pygmy Blue larvae can survive complete submersion in salt water for hours and may even be able to raft on host plant material over the ocean to nearby coastal habitats.

A Disappearing Gem The Karner Blue is one of the most well-known endangered butterflies in the U.S. Although historically found across much of the Midwest into New England and southern Ontario, its population has significantly declined, primarily due to habitat loss. Wisconsin holds the largest population today and has collaborated with many partners to develop the first-ever statewide habitat conservation plan for a butterfly. It represents a promising new model to advance species recovery.

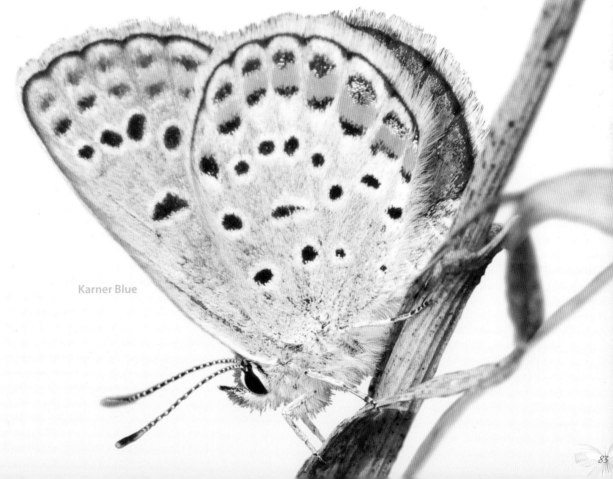

Karner Blue

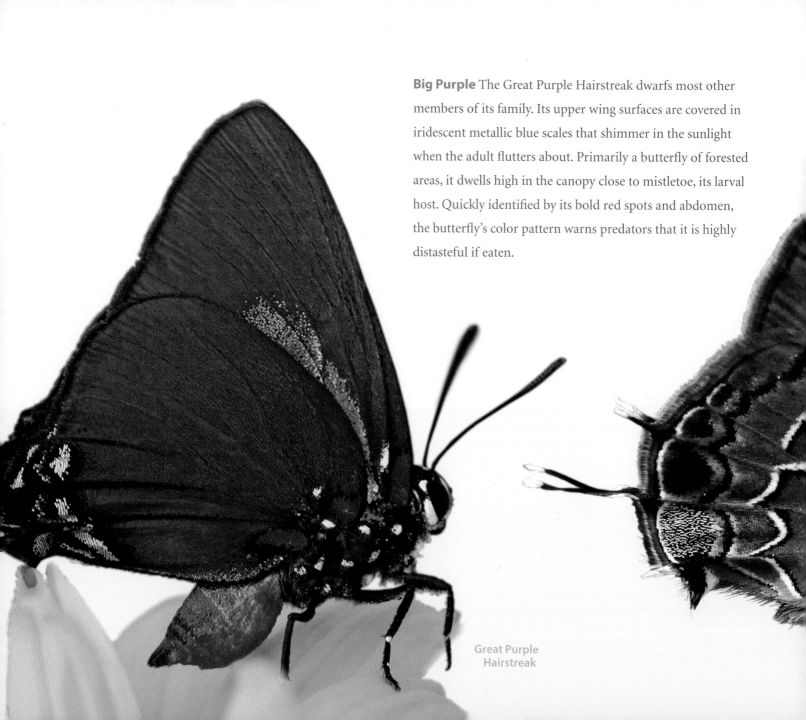

Big Purple The Great Purple Hairstreak dwarfs most other members of its family. Its upper wing surfaces are covered in iridescent metallic blue scales that shimmer in the sunlight when the adult flutters about. Primarily a butterfly of forested areas, it dwells high in the canopy close to mistletoe, its larval host. Quickly identified by its bold red spots and abdomen, the butterfly's color pattern warns predators that it is highly distasteful if eaten.

Great Purple
Hairstreak

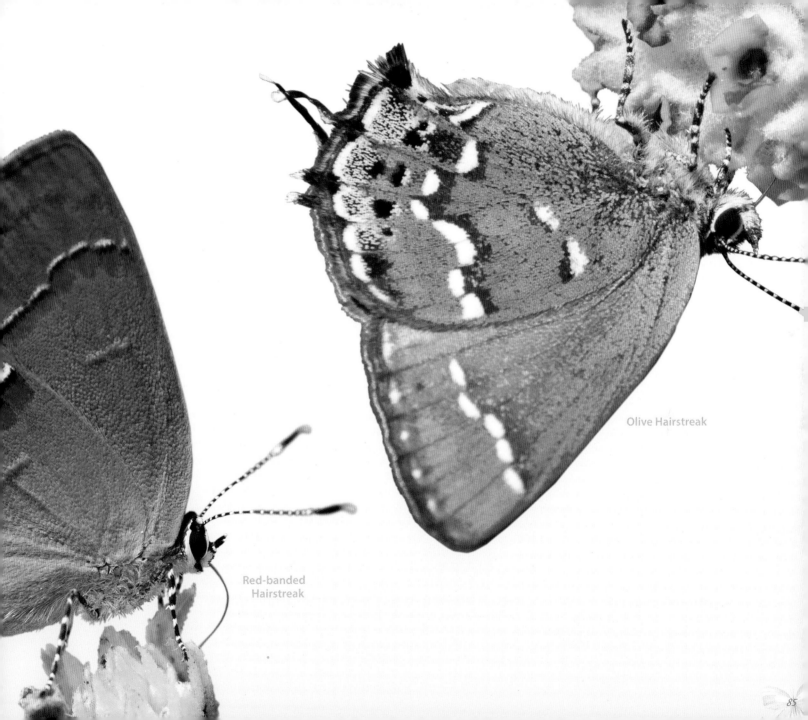

Olive Hairstreak

Red-banded
Hairstreak

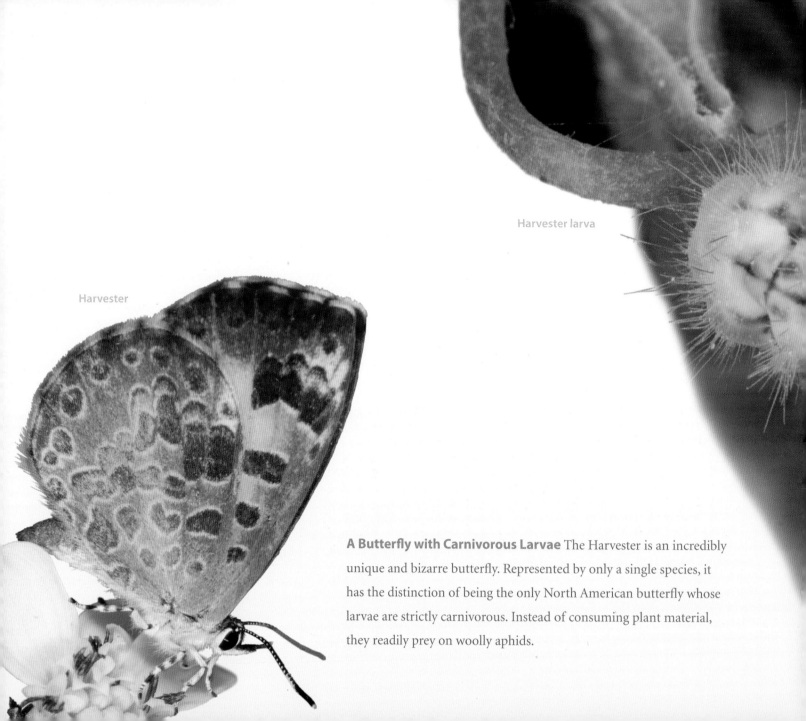

Harvester larva

Harvester

A Butterfly with Carnivorous Larvae The Harvester is an incredibly unique and bizarre butterfly. Represented by only a single species, it has the distinction of being the only North American butterfly whose larvae are strictly carnivorous. Instead of consuming plant material, they readily prey on woolly aphids.

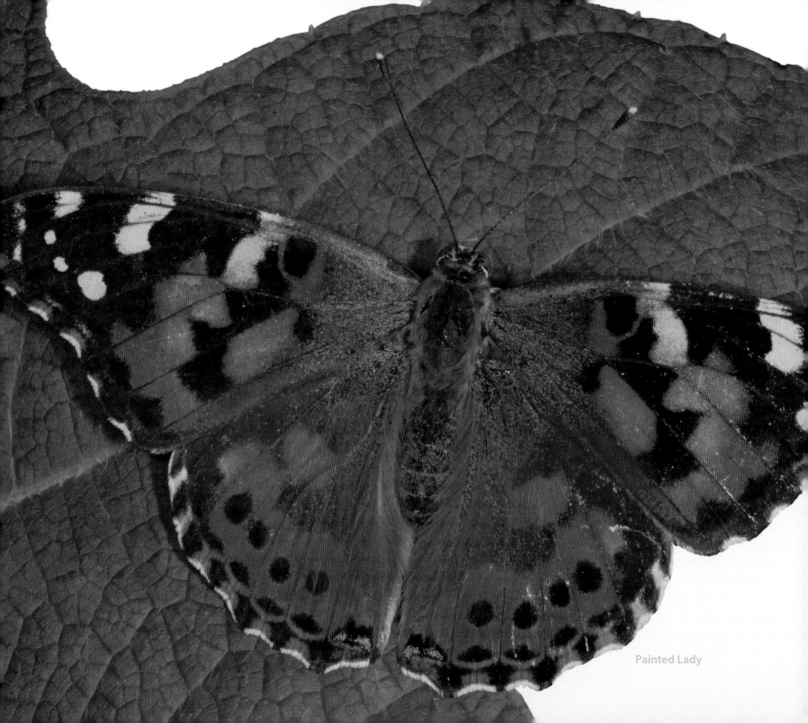

Painted Lady

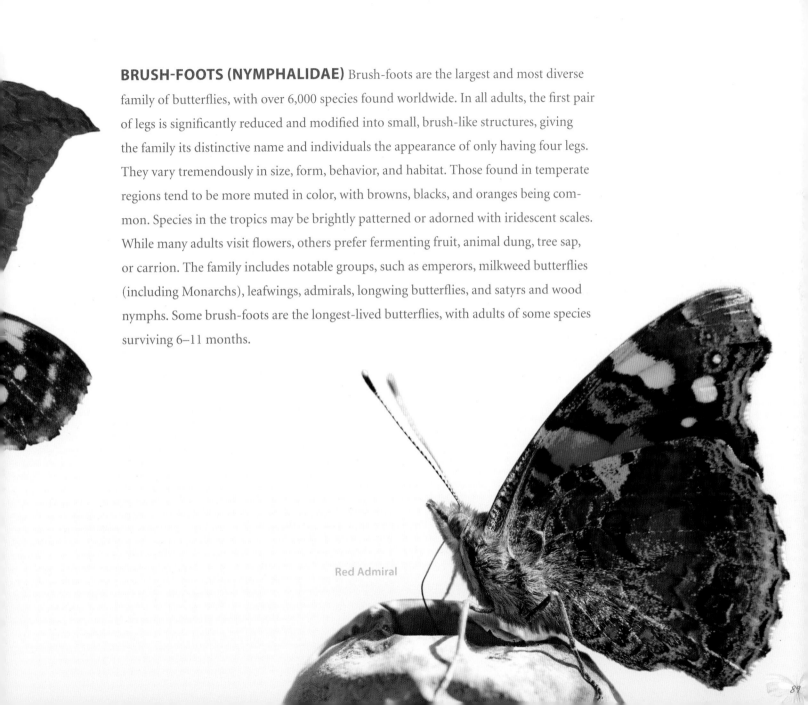

BRUSH-FOOTS (NYMPHALIDAE) Brush-foots are the largest and most diverse family of butterflies, with over 6,000 species found worldwide. In all adults, the first pair of legs is significantly reduced and modified into small, brush-like structures, giving the family its distinctive name and individuals the appearance of only having four legs. They vary tremendously in size, form, behavior, and habitat. Those found in temperate regions tend to be more muted in color, with browns, blacks, and oranges being common. Species in the tropics may be brightly patterned or adorned with iridescent scales. While many adults visit flowers, others prefer fermenting fruit, animal dung, tree sap, or carrion. The family includes notable groups, such as emperors, milkweed butterflies (including Monarchs), leafwings, admirals, longwing butterflies, and satyrs and wood nymphs. Some brush-foots are the longest-lived butterflies, with adults of some species surviving 6–11 months.

Red Admiral

An Unexpected Color As butterflies go, green is a very unusual color. That's why the Malachite is arguably one of the most beautiful and distinctive species in North America. Named for the copper mineral of the same color, it is primarily found in the tropics but can regularly be encountered in southern Florida and Texas. It is also commonly displayed in butterfly houses.

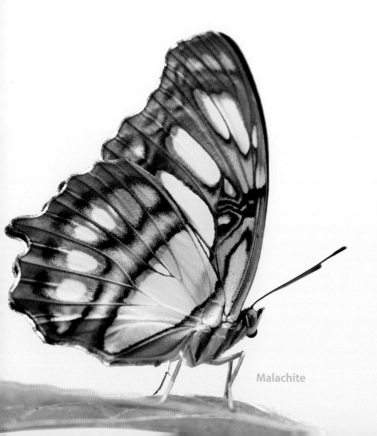

Malachite

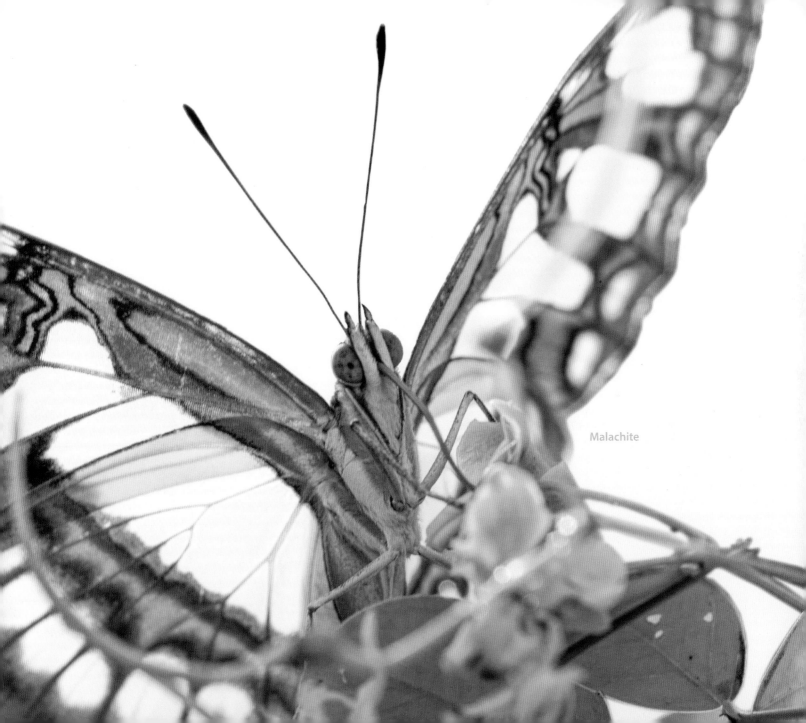

Malachite

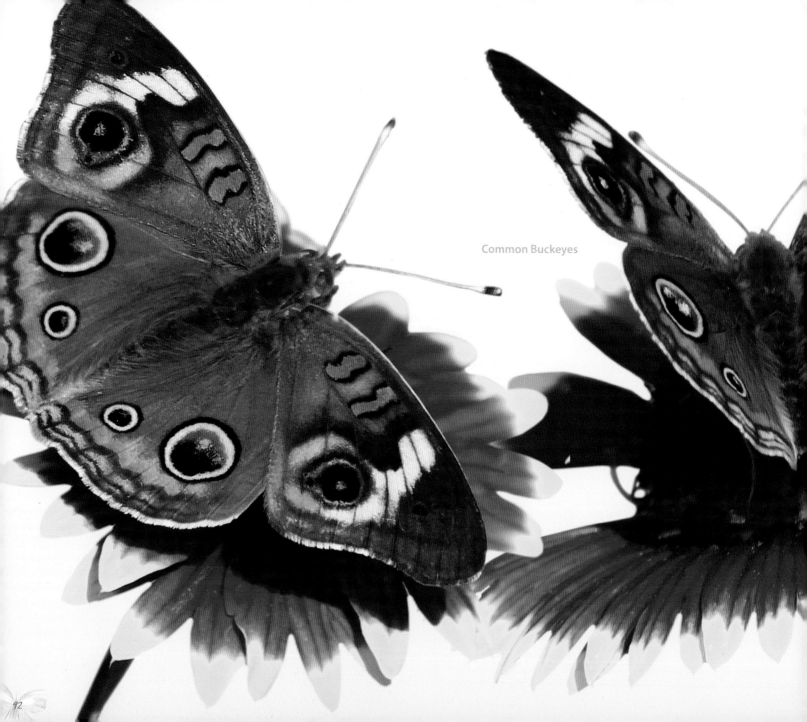

Common Buckeyes

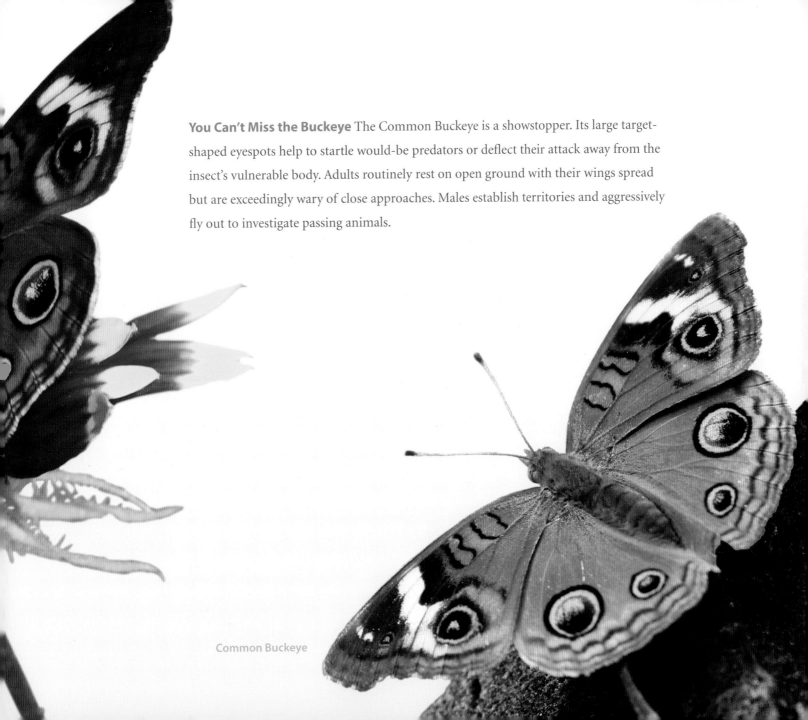

You Can't Miss the Buckeye The Common Buckeye is a showstopper. Its large target-shaped eyespots help to startle would-be predators or deflect their attack away from the insect's vulnerable body. Adults routinely rest on open ground with their wings spread but are exceedingly wary of close approaches. Males establish territories and aggressively fly out to investigate passing animals.

Common Buckeye

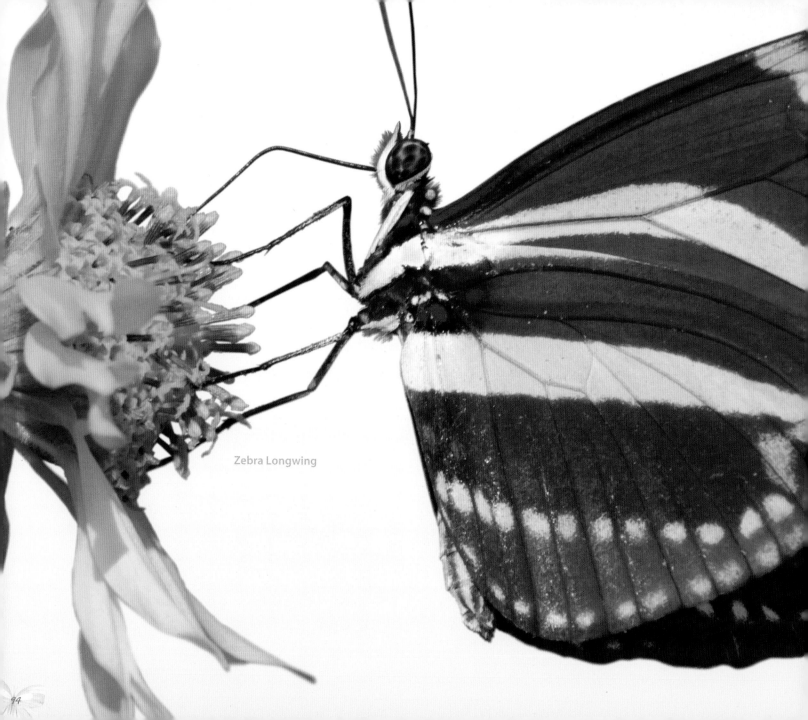

Zebra Longwing

94

Zebra Longwing. Zebra Longwings are distinctive in both appearance and behavior. Adults have elongated wings and a slow, graceful flight. They adeptly maneuver in and through open forested areas and are fervently attracted to available blossoms. As evening approaches, they often gather together to form sizeable roosting aggregations on branches, hanging vines, or Spanish moss. The same communal roost may be used for many consecutive nights.

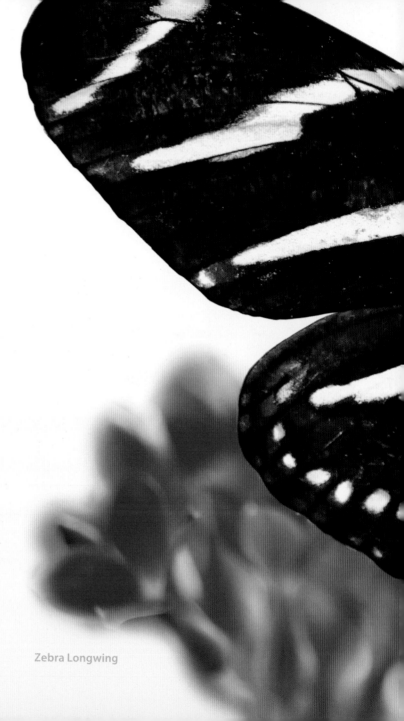

Pupal Mating Representing one of the most unusual behaviors in the butterfly world, male Zebra Longwings engage in what is referred to as pupal mating. They actively survey vegetation in search of chrysalises, specifically those of females that are ready to emerge. One or many males strategically position themselves on the chrysalis and wait. They may even "camp out" for days in anticipation. As soon at the female begins to emerge, they aggressively battle one another for the opportunity to mate with her.

Zebra Longwing

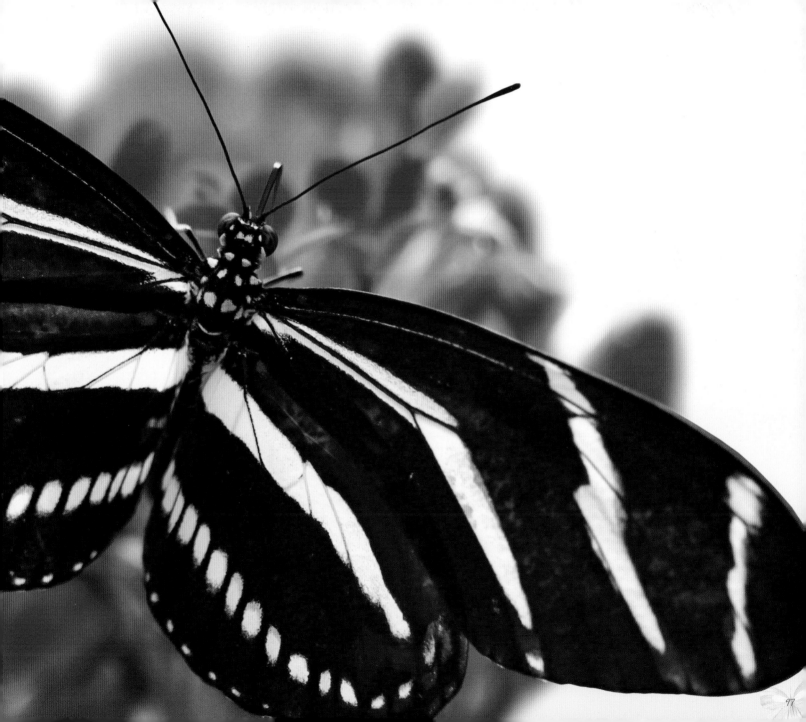

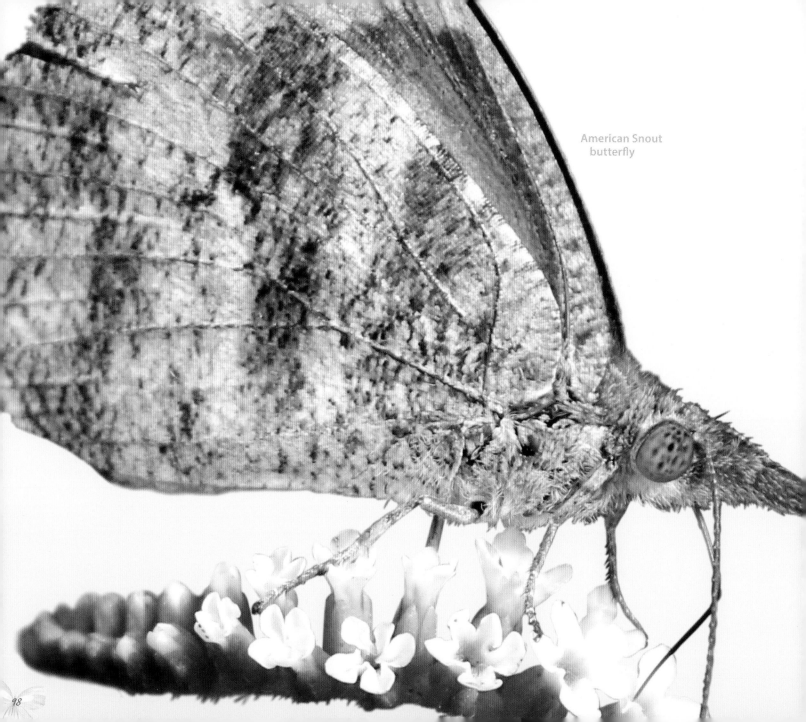

American Snout
butterfly

The American Snout Few butterflies are more peculiar looking than the American Snout. Its odd name refers to the prominent projections on each side of its proboscis that extend forward from its head, resembling an elongated, beak-like nose. This distinctive feature, combined with the mottled-brown color of the hindwings, enhances the butterfly's overall camouflaged "dead leaf" appearance. The species has periodic population explosions accompanied by mass movements. These can often be spectacular in both scale and duration. An outbreak during the 1920s was recorded by scientists; during it, American snouts passed by in an unrelenting fashion for nearly three weeks. The event potentially involved billions of butterflies.

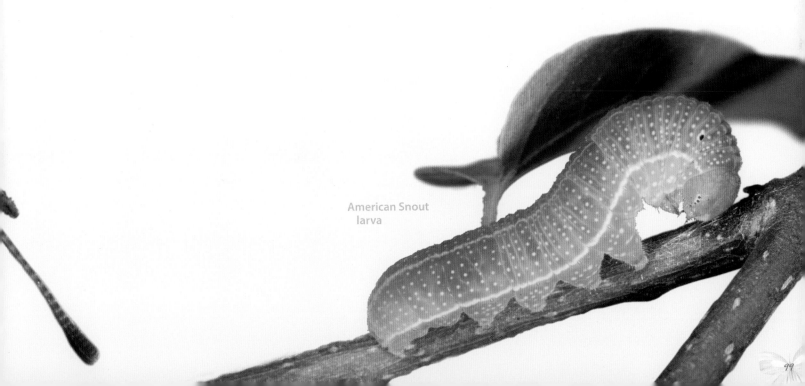

American Snout
larva

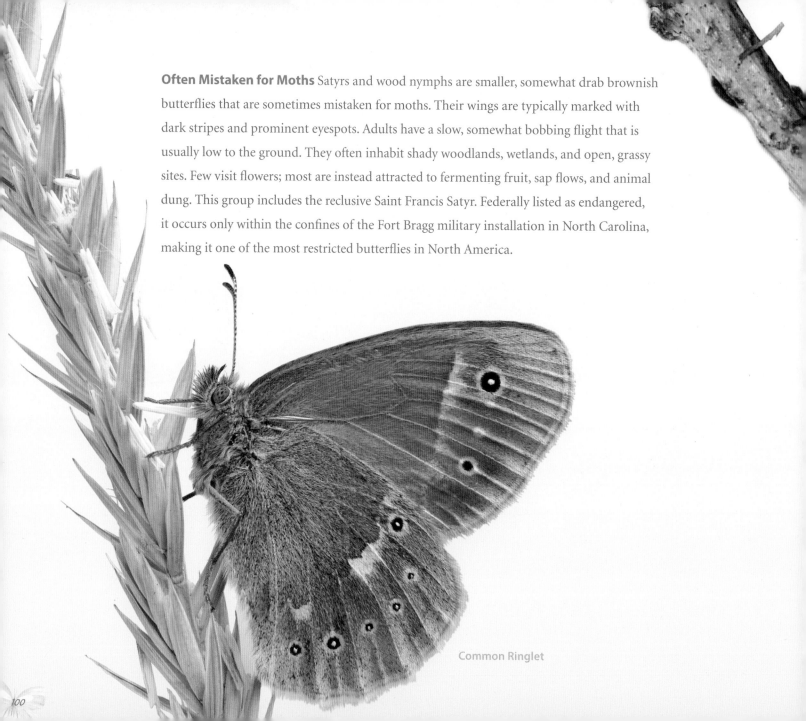

Often Mistaken for Moths Satyrs and wood nymphs are smaller, somewhat drab brownish butterflies that are sometimes mistaken for moths. Their wings are typically marked with dark stripes and prominent eyespots. Adults have a slow, somewhat bobbing flight that is usually low to the ground. They often inhabit shady woodlands, wetlands, and open, grassy sites. Few visit flowers; most are instead attracted to fermenting fruit, sap flows, and animal dung. This group includes the reclusive Saint Francis Satyr. Federally listed as endangered, it occurs only within the confines of the Fort Bragg military installation in North Carolina, making it one of the most restricted butterflies in North America.

Common Ringlet

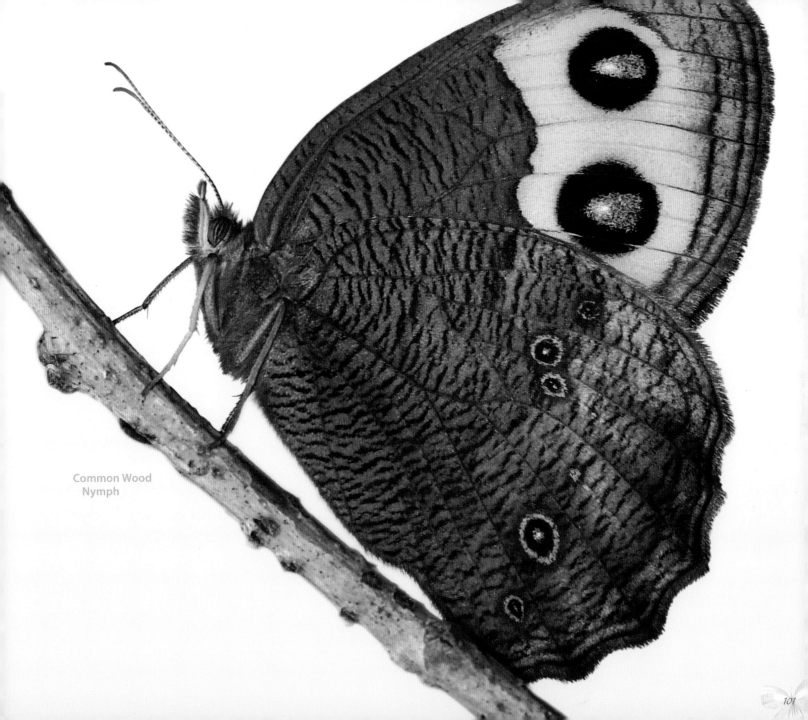

Common Wood
Nymph

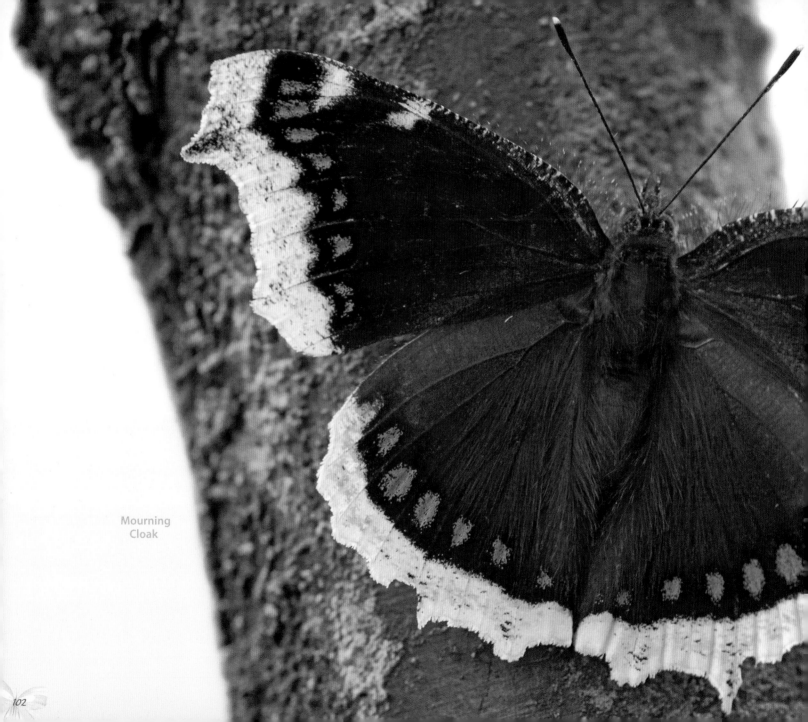

Mourning
Cloak

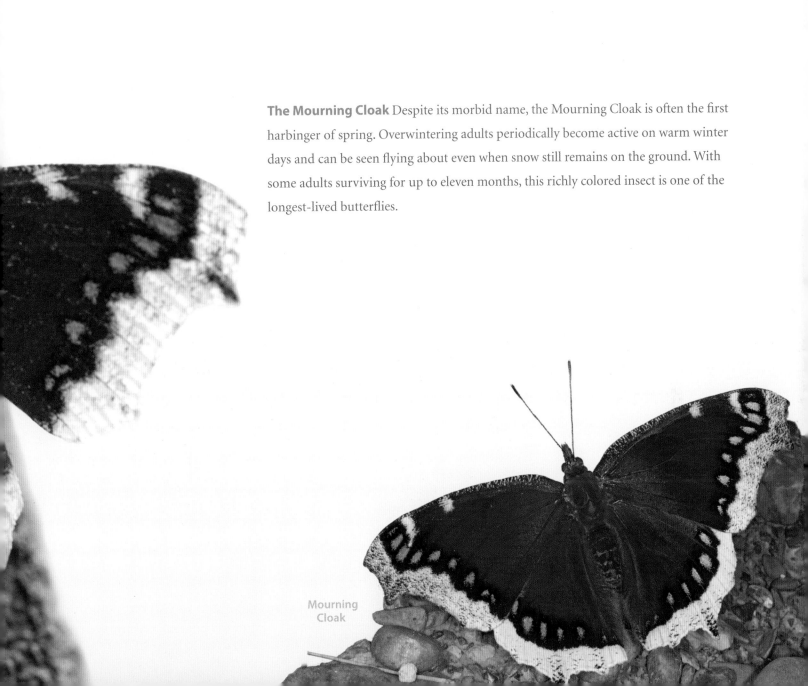

The Mourning Cloak Despite its morbid name, the Mourning Cloak is often the first harbinger of spring. Overwintering adults periodically become active on warm winter days and can be seen flying about even when snow still remains on the ground. With some adults surviving for up to eleven months, this richly colored insect is one of the longest-lived butterflies.

Mourning
Cloak

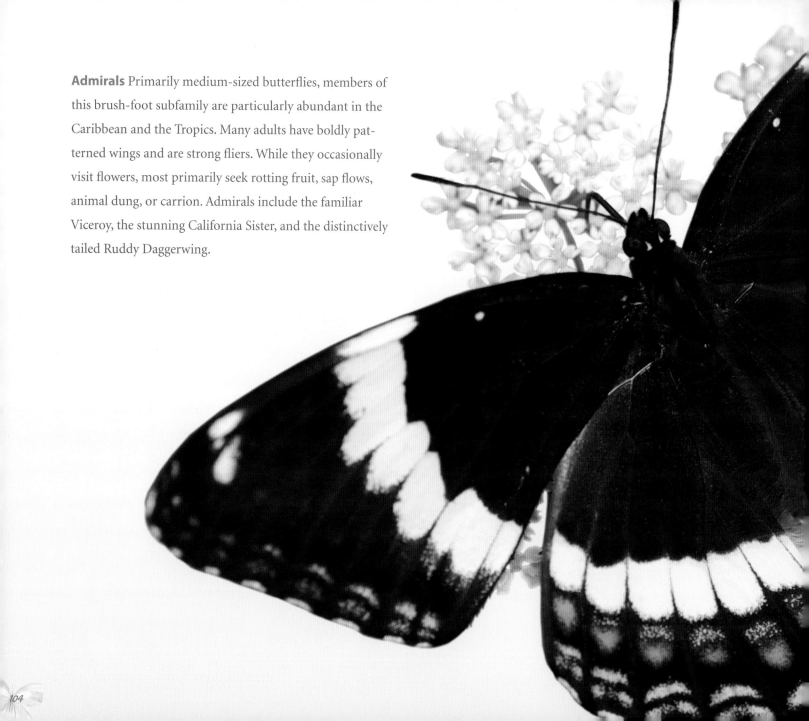

Admirals Primarily medium-sized butterflies, members of this brush-foot subfamily are particularly abundant in the Caribbean and the Tropics. Many adults have boldly patterned wings and are strong fliers. While they occasionally visit flowers, most primarily seek rotting fruit, sap flows, animal dung, or carrion. Admirals include the familiar Viceroy, the stunning California Sister, and the distinctively tailed Ruddy Daggerwing.

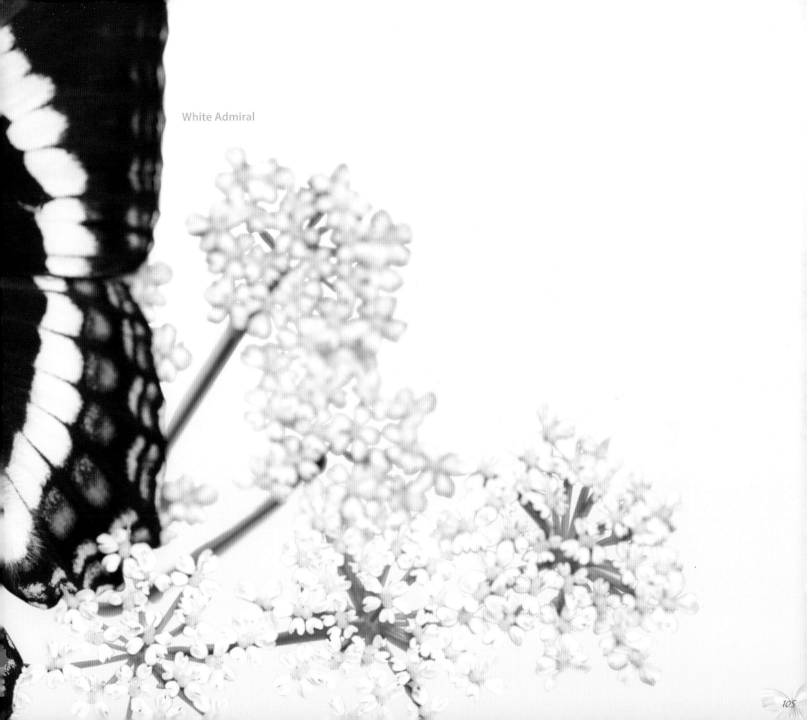

White Admiral

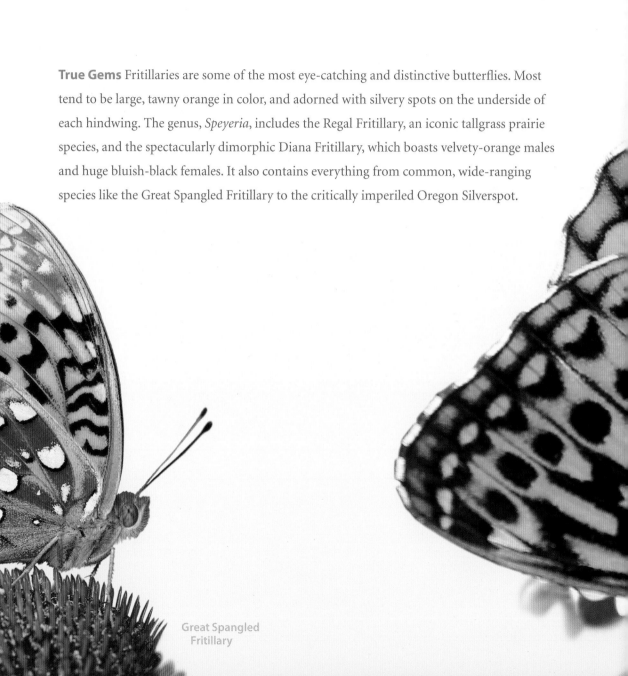

True Gems Fritillaries are some of the most eye-catching and distinctive butterflies. Most tend to be large, tawny orange in color, and adorned with silvery spots on the underside of each hindwing. The genus, *Speyeria*, includes the Regal Fritillary, an iconic tallgrass prairie species, and the spectacularly dimorphic Diana Fritillary, which boasts velvety-orange males and huge bluish-black females. It also contains everything from common, wide-ranging species like the Great Spangled Fritillary to the critically imperiled Oregon Silverspot.

Great Spangled
Fritillary

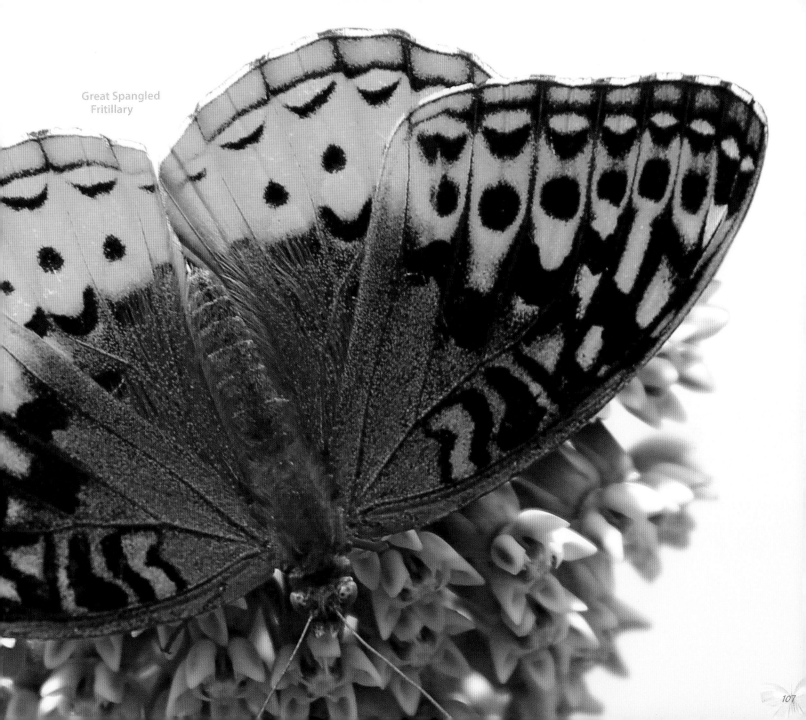

Great Spangled
Fritillary

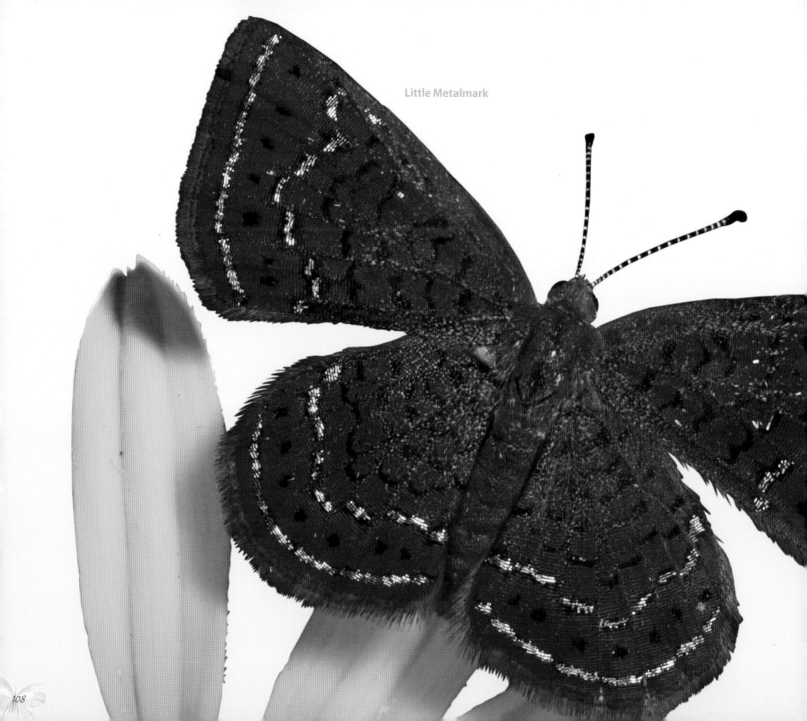

Little Metalmark

METALMARKS (RIODINIDAE) These small butterflies are closely related to Gossamer Wings. They are named for the bright metallic flecks on their wings. In the tropics, metalmarks vary tremendously in terms of color and form and commonly mimic butterflies of virtually every other family, as well as many moth groups. Most U.S. species are more muted in appearance, occurring in various shades of rust, gray, or brown. Adults are weak fliers and somewhat moth-like in behavior. They characteristically perch with their wings outstretched, often posing head down or landing on the underside of leaves.

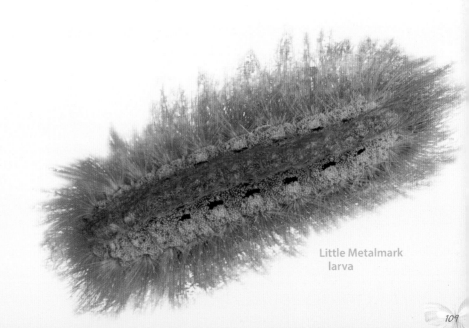

Little Metalmark
larva

The Blue Metalmark The spectacular Blue Metalmark bucks the norm. Unlike most U.S. metalmark species, which are relatively drab, it boasts dazzling metallic aquamarine wings. A subtropical resident from Central America and north to extreme southern Texas, it is a highlight on the life lists of most butterfly watchers.

Many metalmarks are limited in range and quite local in abundance. Some, like the Swamp Metalmark, have become increasingly rare due to habitat loss and fragmentation. Populations are typically small and restricted to increasingly isolated wetland habitats. Others, such as federally endangered Lange's Metalmark, have suffered a similar fate. Its remaining California populations occur almost exclusively within the Antioch Dunes National Wildlife Refuge, which spans less than 60 total acres.

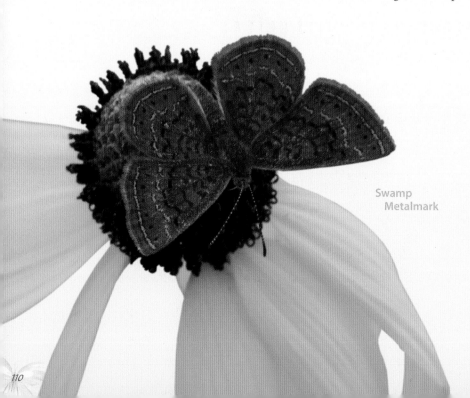

Swamp
Metalmark

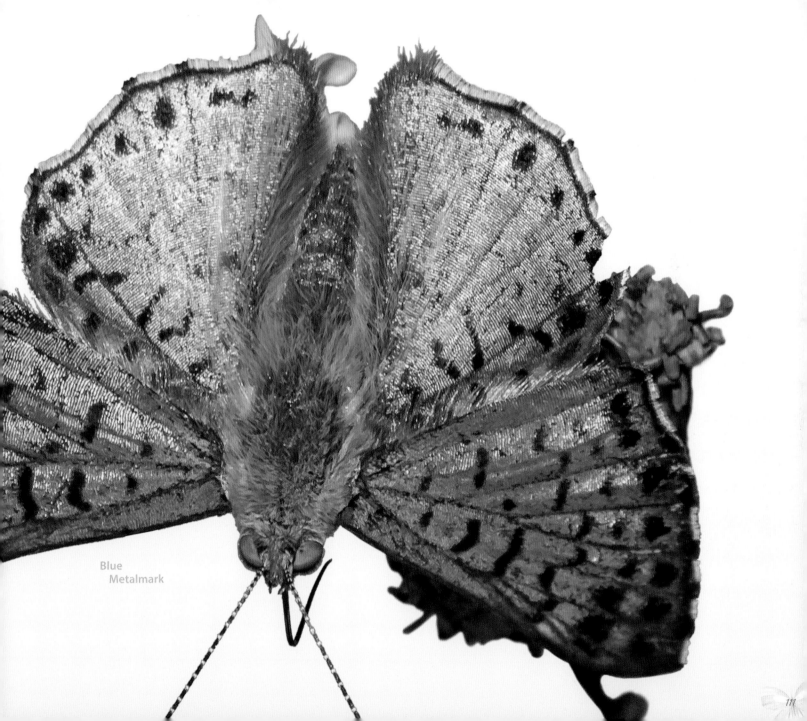

Blue
Metalmark

111

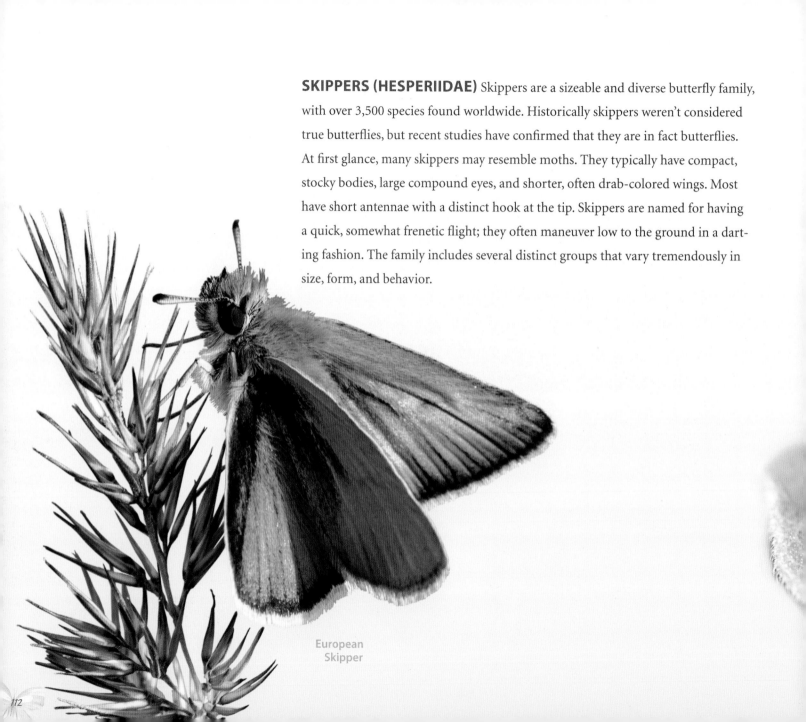

SKIPPERS (HESPERIIDAE) Skippers are a sizeable and diverse butterfly family, with over 3,500 species found worldwide. Historically skippers weren't considered true butterflies, but recent studies have confirmed that they are in fact butterflies. At first glance, many skippers may resemble moths. They typically have compact, stocky bodies, large compound eyes, and shorter, often drab-colored wings. Most have short antennae with a distinct hook at the tip. Skippers are named for having a quick, somewhat frenetic flight; they often maneuver low to the ground in a darting fashion. The family includes several distinct groups that vary tremendously in size, form, and behavior.

European
Skipper

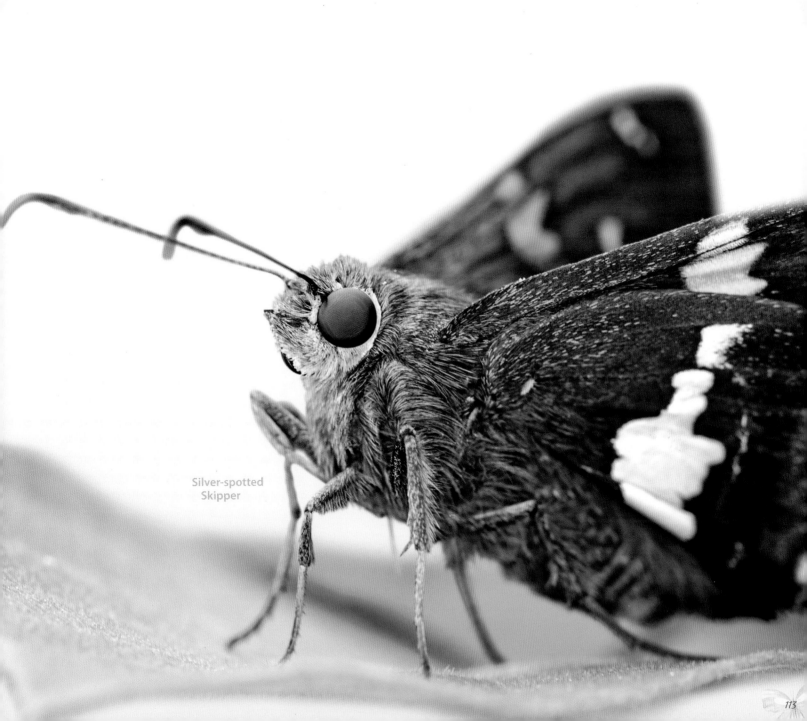

Silver-spotted
Skipper

Grass Skippers Grass Skippers include some of the more abundant and noticeable butterfly species. Most tend to be rather small and are brown or orange with somewhat pointed forewings. Most are exceedingly fond of flowers. Adults often perch or feed in a characteristic posture that resembles a fighter jet. They hold their forewings partially open with the hindwings separated and lowered further. As the name suggests, their larvae feed predominately on grasses or sedges. Because of this diet, some species frequent disturbed habitats, golf courses, or even suburban yards where turf or weedy grasses dominate. Still others are far more specialized and are restricted to particular hosts and habitats.

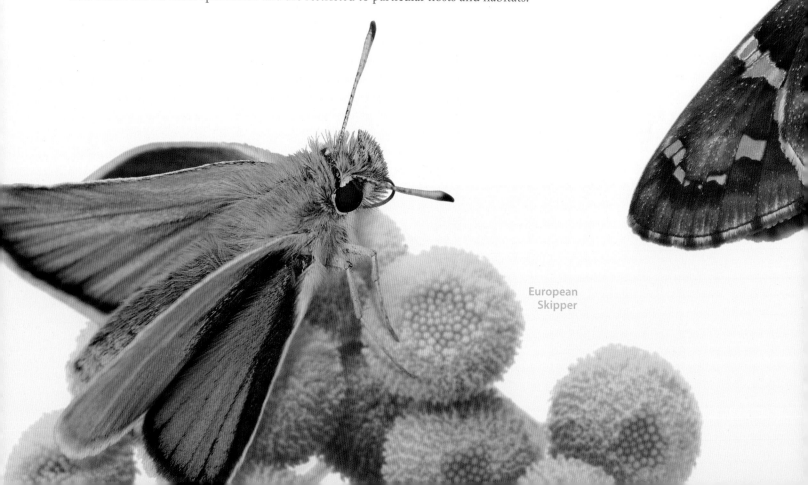

European Skipper

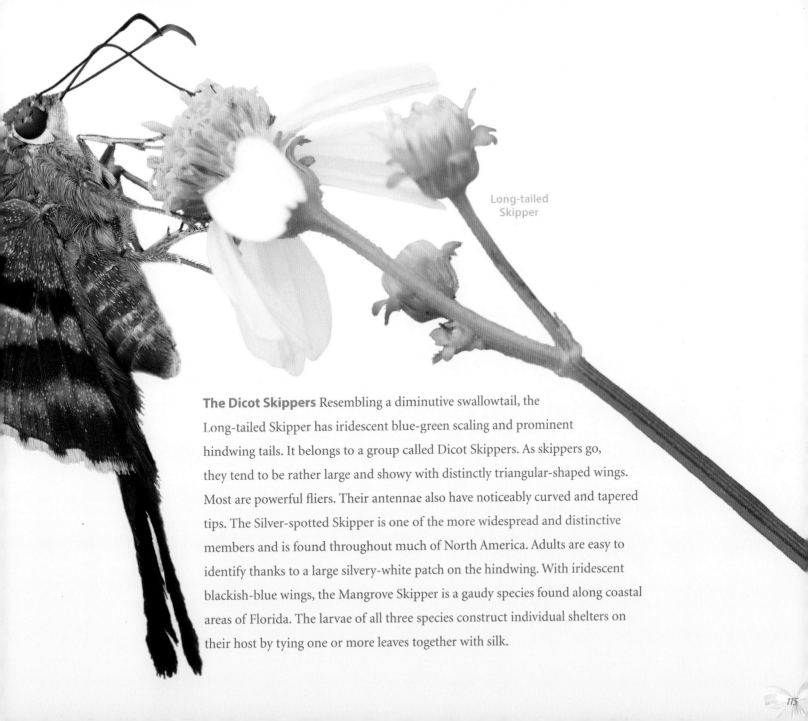

Long-tailed
Skipper

The Dicot Skippers Resembling a diminutive swallowtail, the Long-tailed Skipper has iridescent blue-green scaling and prominent hindwing tails. It belongs to a group called Dicot Skippers. As skippers go, they tend to be rather large and showy with distinctly triangular-shaped wings. Most are powerful fliers. Their antennae also have noticeably curved and tapered tips. The Silver-spotted Skipper is one of the more widespread and distinctive members and is found throughout much of North America. Adults are easy to identify thanks to a large silvery-white patch on the hindwing. With iridescent blackish-blue wings, the Mangrove Skipper is a gaudy species found along coastal areas of Florida. The larvae of all three species construct individual shelters on their host by tying one or more leaves together with silk.

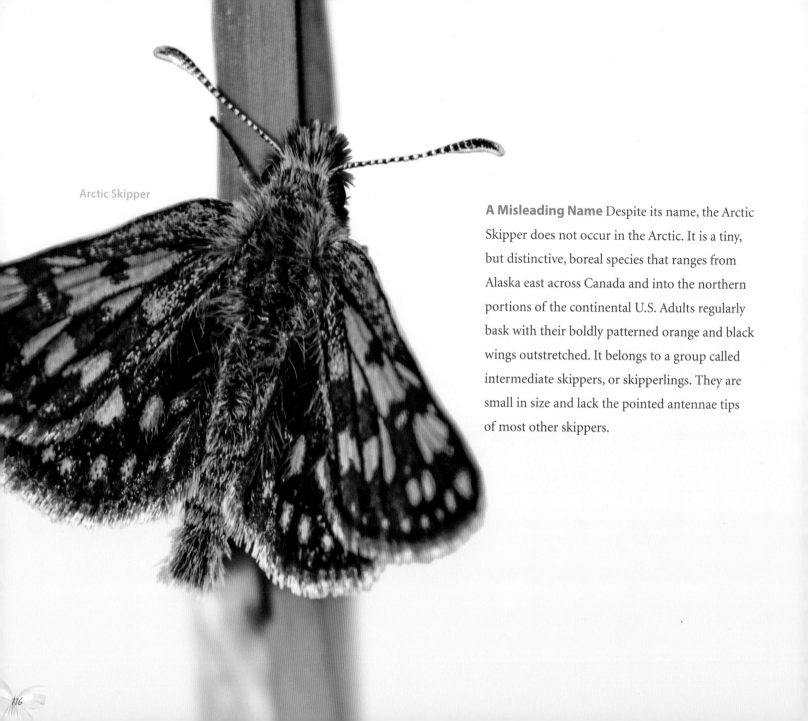

Arctic Skipper

A Misleading Name Despite its name, the Arctic Skipper does not occur in the Arctic. It is a tiny, but distinctive, boreal species that ranges from Alaska east across Canada and into the northern portions of the continental U.S. Adults regularly bask with their boldly patterned orange and black wings outstretched. It belongs to a group called intermediate skippers, or skipperlings. They are small in size and lack the pointed antennae tips of most other skippers.

Spread-wing Skippers Globally diverse and widespread, Spread-wing Skippers are the second-largest skipper subfamily. Adults, such as the Common Checkered Skipper, regularly perch and feed with their wings outstretched. Predominately colored in shades of white, brown, or gray, most U.S. species are fairly drab in appearance. A great many are similar-looking and can be frustratingly challenging to identify. Those in tropical regions are often more vibrantly patterned.

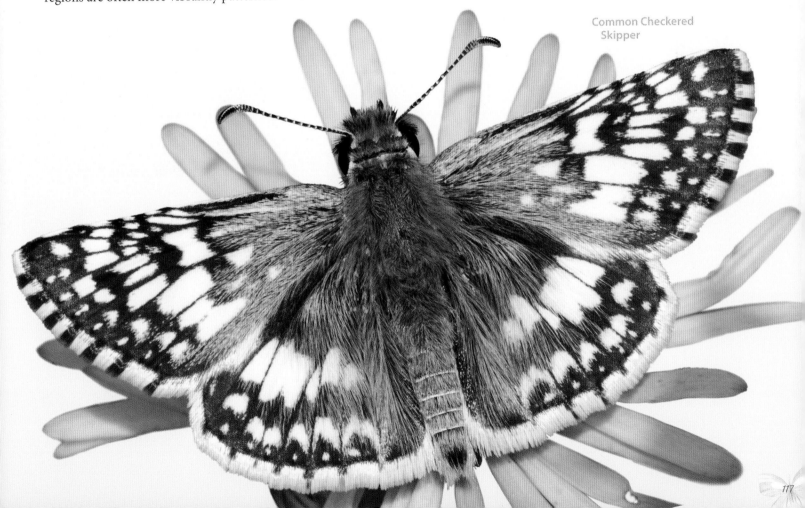

Common Checkered Skipper

Why Butterflies are Important

Butterflies are a diverse group of insects and include some of the most attractive and popular species on Earth. Common backyard visitors, they have also been actively studied for over 300 years and are an intimate part of our collective natural heritage. Beyond their broad appeal, butterflies play a number of important roles in the wider ecosystem and serve as a model that helps scientists better understand environmental change, and their status as natural icons helps promote conservation awareness and action.

POLLINATION Butterflies are also important as pollinators. Pollinators, most of them insects, are critical to our environment and economic well-being because they help some 80 percent of the flowering plants on Earth reproduce. This includes the vast majority of the fruit, vegetable, and seed crops that humans consume, as well as many other plants of commercial or medicinal value. Beyond the direct economic value to humans, insect pollination is essential to the structure and function of a wide range of natural communities. While wild and managed bees are arguably the most efficient pollinators, many other insects, including flies, beetles, wasps, moths, and butterflies also play a significant role. Butterflies in particular tend to make more flower visits than bees and are more resilient to habitat and landscape changes. As a group, they display tremendous diversity in life history, behavior, size, and form. Such rich species assemblages have been shown make them effective pollinators, and their presence in the environment also serves as a sort of insurance against continued declines in bee populations.

FOOD FOR OTHER ORGANISMS Insects, including butterflies, are important members of wider food webs. A wide range of organisms, including other insects, spiders, amphibians, reptiles, birds, and mammals, feed on butterflies and other insects. In many ways, when insects are diverse and abundant, the wider environment thrives. This is often because insects provide a rich and stable assortment of food resources.

Songbirds are a good example. While they often consume seeds, berries, and fruit, a protein-rich diet is generally required when they are breeding. When nesting, songbirds will tirelessly collect caterpillars and other insects to feed their developing young. For every clutch of hungry babies, thousands of prey items are needed to complete development, making this a herculean effort. So in a very real sense, one cannot be a true bird lover without first having tremendous appreciation for insects, especially caterpillars.

NUTRIENT RECYCLING Most butterflies spend a substantial portion of their lives as larvae. During development, they consume and digest plant material. They also of course produce waste in the form of droppings or pellets called frass. In doing so, they release nutrients, including nitrogen and phosphorous, back into the soil. This increases nutrient availability and ultimately improves the quality of soils, which further enhances plant growth and productivity.

ENVIRONMENTAL INDICATORS Butterflies are also useful as environmental indicators, and they have long been considered a model group for studying environmental change. In fact, they are the best-monitored insects on the planet. Unlike larger organisms, such as birds or mammals, butterflies have short life cycles and are closely tied to plant communities. As a result, they react quickly to even subtle habitat or climatic changes and can be used to help predict the impact that such changes may have on other organisms. Because they're easy to monitor, butterflies are also useful to assess an area's biodiversity. As it is nearly impossible to rapidly and effectively survey all life in a particular area, evaluating specific indicator groups that are representative of the wider environment is a common tool used by scientists. Such an approach is often useful to help identify and prioritize sites for conservation. Butterflies have also been used to help evaluate the influence of different habitat management and restoration practices. In many ways, they are truly the canary in the coal mine.

Conservation & How You Can Help

Species conservation is often a popularity contest. Large, showy, or otherwise charismatic organisms often get the most attention. This is certainly true for insects. The vast majority of species listed as threatened, endangered, or of conservation concern by the federal government or individual states are butterflies. Most other insects are left out. This unfair playing field is not all bad. Because of their broad public appeal, butterflies are ideal ambassadors that serve to raise awareness and engender broad public support for larger conservation programs. The beloved Monarch butterfly, for instance, has helped champion efforts to reverse pollinator declines.

Similarly, some butterflies may be ideal umbrella species. As the metaphor implies, these are organisms whose conservation provides broader protection for other species that share the same habitat. For example, the federally endangered Schaus Swallowtail is a large iconic butterfly found only in South Florida. It inhabits dense subtropical forests called hammocks that are extremely limited in range and which harbor many rare or endemic species. Safeguarding this single butterfly provides a powerful protective umbrella over its entire wider natural community.

BUTTERFLY CONSERVATION TIPS

Become familiar with the butterflies in your area. Buy a good field guide, participate in local field trips, and spend time outside to learn to identify the species you observe.

Participate in citizen science. Numerous projects allow you to directly contribute valuable data for scientific research. Record your sightings, share pictures and other observations, and network with others.

Plant a butterfly or pollinator garden. Help provide needed resources and beautify your landscape in the process. Use native plants whenever possible. Include host plants to support butterfly caterpillars and flowering plants that provide nectar for adult butterflies. Select flowers that vary in size, shape, and bloom time, and avoid using pesticides. See page 129 for examples.

Support or volunteer at a local nature center, wildlife refuge, park, or conservation-based organization.

BUTTERFLY HOUSES Millions of people travel to see butterflies each year. Attractions such as butterfly houses are particularly popular. These enclosed, walk-through displays showcase free-flying butterflies, often exotic species from tropical forest countries around the world, typically in a tropical or flower-rich landscape. They offer a truly unique educational and highly immersive experience unlike any other exhibit. They are often associated with zoos, museums, or botanical gardens. Dozens of temporary or permanent butterfly houses can be found in North America and many more occur in other countries. A number of the species in this book are nonnative butterflies commonly seen at such "living exhibits."

WATCHING WILDLIFE AND BUTTERFLY GARDENING Wildlife watching is one of the most popular forms of outdoor recreation and continues to grow each year. Estimates indicate that over a third of the American population engages in some form of nature viewing, and the economic impact of these activities is in the billions. While bird watching accounts for a significant share, more and more people are gravitating toward butterflies and other insects. They are increasingly interested in developing life lists and participating in butterfly counts or other citizen science monitoring activities, with some butterfly fans even traveling extensive distances on butterfly-related ecotours.

BUTTERFLIES IN YOUR BACKYARD You don't need to travel to enjoy butterflies. Gardening with butterflies in mind is a great way to bring butterflies and other wildlife to you. Interest in landscaping for wildlife, especially birds, butterflies, and other pollinators, has grown rapidly in the past decade. It allows individuals and families to get up-close-and-personal with local wildlife and help create important habitat pockets in an increasingly fragmented environment. This is especially true if you limit pesticide use and plant native larval hosts and adult nectar plants. Such a living landscape is highly enjoyable and adds beauty, wonder, and sometimes even value to your property. See page 129 for a list of butterfly-friendly plants for your region.

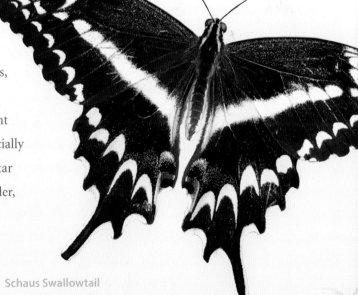

Schaus Swallowtail

Commonly Seen Caterpillars and the Butterflies and Moths They Become

 Monarch Caterpillar

 Monarch Butterfly

 Luna Moth Caterpillar

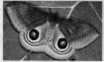 Luna Moth

 Hickory Horned Devil

 Regal Moth

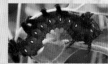 Io Moth Caterpillar

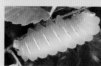 Io Moth

 Imperial Moth Caterpillar

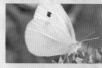 Imperial Moth

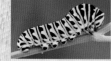 Cabbage White Caterpillar

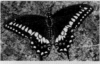 Cabbage White Butterfly

Black Swallowtail Caterpillar/ Parsley Worm

Black Swallowtail Butterfly

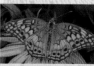 Variegated Fritillary Caterpillar

 Variegated Fritillary Butterfly

 Red Admiral Caterpillar

 Red Admiral Butterfly

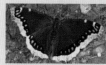 Mourning Cloak Caterpillar

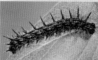 Mourning Cloak Butterfly

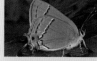 Gray Hairstreak Caterpillar

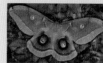 Gray Hairstreak Butterfly

 Polyphemus Moth Caterpillar

 Polyphemus Moth

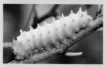 Common Buckeye Caterpillar

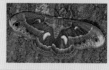 Common Buckeye Butterfly

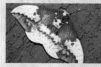 Cecropia Moth Caterpillar

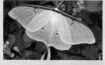 Cecropia Moth

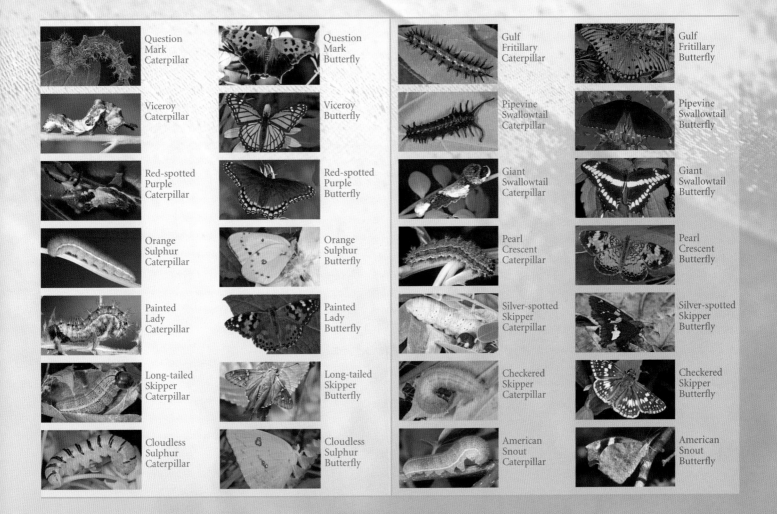

Question Mark Caterpillar

Question Mark Butterfly

Gulf Fritillary Caterpillar

Gulf Fritillary Butterfly

Viceroy Caterpillar

Viceroy Butterfly

Pipevine Swallowtail Caterpillar

Pipevine Swallowtail Butterfly

Red-spotted Purple Caterpillar

Red-spotted Purple Butterfly

Giant Swallowtail Caterpillar

Giant Swallowtail Butterfly

Orange Sulphur Caterpillar

Orange Sulphur Butterfly

Pearl Crescent Caterpillar

Pearl Crescent Butterfly

Painted Lady Caterpillar

Painted Lady Butterfly

Silver-spotted Skipper Caterpillar

Silver-spotted Skipper Butterfly

Long-tailed Skipper Caterpillar

Long-tailed Skipper Butterfly

Checkered Skipper Caterpillar

Checkered Skipper Butterfly

Cloudless Sulphur Caterpillar

Cloudless Sulphur Butterfly

American Snout Caterpillar

American Snout Butterfly

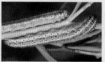
Checkered White Caterpillar

Checkered White Butterfly

Variable Checkerspot Caterpillar

Variable Checkerspot Butterfly

Sleepy Orange Caterpillar

Sleepy Orange Butterfly

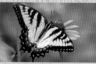
Eastern Tiger Swallowtail Caterpillar

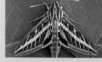
Eastern Tiger Swallowtail Butterfly

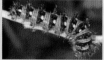
American Lady Caterpillar

American Lady Butterfly

White-lined sphinx Caterpillar

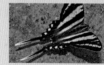
White-lined Sphinx Moth

Great Purple Hairstreak Caterpillar

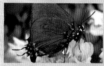
Great Purple Hairstreak Butterfly

Zebra Swallowtail Caterpillar

Zebra Swallowtail Butterfly

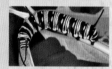
Queen Caterpillar

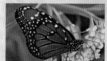
Queen Butterfly

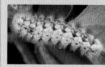
Harvester Caterpillar

Harvester Butterfly

Little Yellow Caterpillar

Little Yellow Butterfly

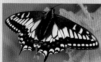
Anise Swallowtail Caterpillar

Anise Swallowtail Butterfly

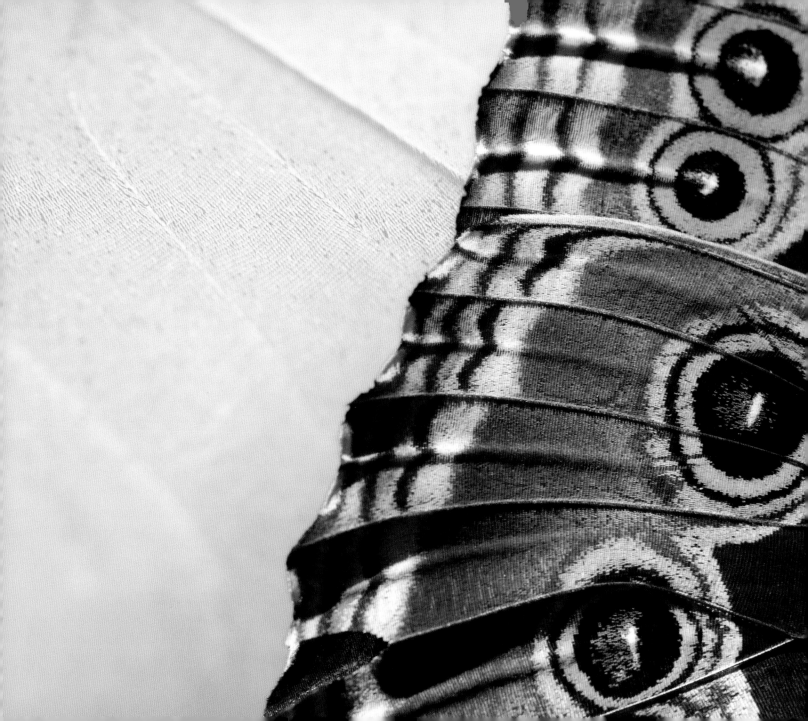

Common Native Butterfly Species

ALL OR MOST OF U.S.

Monarch
Danaus plexippus

Red Admiral
Vanessa atalanta

Mourning Cloak
Nymphalis antiopa

Painted Lady
Vanessa cardui

Cabbage White
Pieris rapae

Viceroy
Limenitis archippus

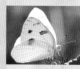
Checkered White
Pontia protodice

Common
Wood Nymph
Cercyonis pegala

Orange Sulphur
Colias eurytheme

Silver-spotted
Skipper
Epargyreus clarus

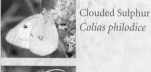
Clouded Sulphur
Colias philodice

Gray Hairstreak
Strymon melinus

EASTERN U.S.

Eastern Tiger
Swallowtail
Papilio glaucus

Little Wood Satyr
Megisto cymela

Black Swallowtail
Papilio polyxenes

Horace's
Duskywing
Erynnis horatius

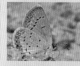
Eastern Tailed Blue
Cupido comyntas

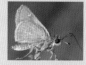
Common
Checkered Skipper
Pyrgus communis

Pearl Crescent
Phyciodes tharos

Tawny-edged
Skipper
Polites themistocles

Question Mark
*Polygonia
interrogationis*

American Lady
Vanessa virginiensis

Red-spotted Purple/
White Admiral
Limenitis arthemis

WESTERN U.S.

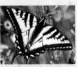
Western Tiger Swallowtail
Papilio rutulus

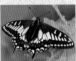
Anise Swallowtail
Papilio zelicaon

Acmon Blue
Plebejus acmon

Boisduval's Blue
Plebejus icarioides

Variable Checkerspot
Euphydryas chalcedona

NORTHERN AND CENTRAL U.S.

Coral Hairstreak
Satyrium titus

Great Spangled Fritillary
Speyeria cybele

SOUTHERN U.S.

Pipevine Swallowtail
Battus philenor

Cloudless Sulphur
Phoebis sennae

Sleepy Orange
Abaeis nicippe

Gulf Fritillary
Agraulis vanillae

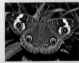
Common Buckeye
Junonia coenia

Fiery Skipper
Hylephila phyleus

Nonnative Butterfly Species Commonly on Display in Living Exhibits

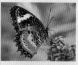 Red Lacewing
Cethosia biblis

 Grecian Shoemaker
Catonephele numilia

 Clipper Swallowtail
Parthenos sylvia

 Postman
Heliconius melpomene

 Mimic Eggfly
Hypolimnas misippus

 Owl
Caligo memnon

 Small Postman
Heliconius erato

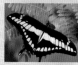 Thoas Swallowtail
Papilio thoas

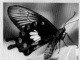 Common Rose
Pachliopta aristolochiae

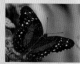 Scarlet Peacock
Anartia amathea

 Dido
Philaethria dido

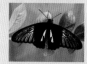 Golden Birdwing
Troides rhadamantus

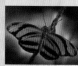 Banded Orange
Dryadula phaetusa

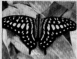 Tailed Jay
Graphium agamemnon

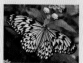 Tree Nymph
Idea leuconoe

 Julia
Dryas iulia

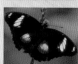 Great Eggfly
Hypolimnas bolina

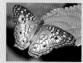 White Peacock
Anartia jatrophae

 Tiger Longwing
Heliconius ismenius

 Blue Morpho
Morpho peleides

Butterfly-friendly Plants, by Region

Midwest and Northeast

Purple Coneflower (*Echinacea purpurea*)

Pink Swamp Milkweed (*Asclepias incarnata*)

Wild Bergamot (*Monarda fistulosa*)

New England Aster (*Symphyotrichum novae-angliae*)

Joe-Pye Weed (*Eutrochium maculatum* or *Eutrochium purpureum*)

Goldenrod (*Solidago* spp.)

Obedient Plant (*Physostegia virginiana*)

Gayfeather (*Liatris* spp.)

Southeast

Purple Passionflower (*Passiflora incarnata*)

Butterflyweed (*Asclepias tuberosa*)

Cutleaf Coneflower (*Rudbeckia laciniata*)

Mistflower (*Conoclinium coelestinum*)

Joe-Pye Weed (*Eutrochium fistulosum*)

Ironweed (*Vernonia* spp.)

Obedient Plant (*Physostegia virginiana*)

Eastern Bluestar (*Amsonia tabernaemontana*)

Firebush (*Hamelia patens*)

Northwest and California

Showy Milkweed (*Asclepias speciosa*)

Ceanothus (*Ceanothus* spp.)

Fireweed (*Chamerion angustifolium*)

Camas (*Camassia quamash*)

Indian Paintbrush (*Castilleja* spp.)

Goldenrod (*Solidago* spp.)

Checkerbloom (*Sidalcea* spp.)

Meadowsweet (*Spiraea* spp.)

Oceanspray (*Holodiscus discolor*)

Lupine (*Lupinus* spp.)

Salvia (*Salvia* spp.)

Texas and Great Plains

Antelope Horns (*Asclepias asperula*)

Butterflyweed (*Asclepias tuberosa*)

Passionflower (*Passiflora* spp.)

Salvia (*Salvia* spp.)

Beebalm (*Monarda* spp.)

Mistflower (*Conoclinium coelestinum*)

New Jersey Tea (*Ceanothus americanus*)

Goldenrod (*Solidago* spp.)

Gayfeather (*Liatris* spp.)

Desert and Mountain West

Goldenrod (*Solidago* spp.)

Showy Milkweed (*Asclepias speciosa*)

Antelope Horns (*Asclepias asperula*)

Mock Vervain (*Glandularia* spp.)

Salvia (*Salvia* spp.)

Desertbroom (*Baccharis* spp.)

Acacia (*Acacia* spp.)

Beardtongue (*Penstemon* spp.)

Wallflower (*Erysimum* spp.)

Glossary

ABDOMEN: The last section of the body, that contains the reproductive, digestive, and excretory systems along with a series of lateral holes, called spiracles, for air exchange

ANTENNAE: A pair of elongated sensory structures on the head

ARTHROPOD: Invertebrate organisms that have a segmented body, jointed appendages, and a hard external skeleton

APOSEMATISM: The use of bold colors and patterns by an animal to warn potential predators that it is toxic or distasteful

ANDROCONIA: Modified wing scales found in males that release pheromones during courtship

BUTTERFLY: An insect belonging to the order Lepidoptera; it is typically day-flying with large, often colorful wings, two clubbed antennae, and an elongated body

CATERPILLAR: Also called a larva, it is the worm-like second stage of a butterfly's life cycle

CHITIN: A fibrous substance that forms the wings to the hard external skeleton of insects and other arthropods

CHORION: The hard outer shell of a butterfly or moth egg

CHRYSALIS: Also called a pupa, the third stage of a butterfly's life cycle between the caterpillar and adult

COCOON: A silken case made by the caterpillar of a moth to protect its pupa

COMPOUND EYES: The eyes of arthropods that are made up of many photoreceptor units

HEAD: The first body section, which bears eyes, mouthparts, and antennae

HEMOLYMPH: The insect equivalent of blood

HOST PLANT: A specific plant on which a caterpillar feeds

LEPIDOPTERA: The insect order that contains butterflies and moths

METAMORPHOSIS: The process of transformation from a work-like caterpillar into a winged adult butterfly or moth

MIMICRY: The resemblance of one organism to another

MIGRATION: Seasonal movement of an organism from one location to another

MOTH: An insect belonging to the order Lepidoptera; it is typically nocturnal with conspicuous, often drab-colored wings, two non-clubbed antennae, and a stout body

OSMETERIUM: Fleshy defensive organ located behind the head in swallowtail caterpillars

PHEROMONE: A volatile chemical produced by an organism that influences the behavior of another member of the same species

PROBOSCIS: The straw-like mouthpart of an adult butterfly that is used to feed on liquid resources

PUPAE: The plural of pupa

TARSI: The final segment (feet) of an insect's legs

THORAX: The second body section directly behind the head which bears legs and wings (in adults)

SCALES: Small, predominantly plate-like structures that make up the color and pattern of the wing

About the Author

Jaret C. Daniels, Ph.D., is an Associate Professor of Entomology at the University of Florida and Director of the McGuire Center for Lepidoptera and Biodiversity at the Florida Museum of Natural History, specializing in insect ecology and conservation. He has authored numerous scientific papers, popular articles, and books on wildlife conservation, insects, and butterflies, including butterfly field guides for Florida, Georgia, the Carolinas, Ohio, and Michigan. He is also the author of *Backyard Bugs: An Identification Guide to Common Insects, Spiders, and More*. Jaret currently lives in Gainesville, Florida, with his wife Stephanie.